Drawings of Leonard da Vinci

(1907)

ISBN-13 : 978-1511952125
ISBN-10 : 1511952121

Copyright©2012-2014 Iacob Adrian
All Rights Reserved.

Notice

This documentary study use historic, archived documents.

Because of this, some pages may look blurry or low quality.

Still are included in this book because they have

high value from critical, documentary, historical,

informative and journalistic point of view .

Dtp and visual art

Iacob Adrian

DRAWINGS OF
LEONARDO DA VINCI

Author statement

This is a series of books about art and history of art .

DRAWINGS OF LEONARDO DA VINCI

This little Book conveys the greetings of

..

to

..

LIST OF ILLUSTRATIONS

	PLATE
PROFILE OF A WARRIOR . . . *Frontispiece*	
PORTRAIT OF ISABELLA D'ESTE	I
STUDY OF AN OLD MAN	II
STUDY OF DRAPERIES FOR KNEELING FIGURES .	III
STUDY OF A BACCHUS	IV
HEAD OF A MAN	V
BATTLE BETWEEN HORSEMEN AND MONSTERS .	VI
WOMAN SEATED ON GROUND AND CHILD KNEELING	VII
STUDIES OF HEADS	VIII
YOUTH ON HORSEBACK	IX
STUDIES FOR THE EQUESTRIAN STATUE OF FRANCESCO SFORZA	X
THE VIRGIN, ST. ANNE AND INFANT . . .	XI
STUDIES OF CHILDREN	XII
THE COMBAT	XIII
STUDY FOR A MADONNA	XIV
STUDIES FOR "THE HOLY FAMILY" . . .	XV
STUDIES FOR "THE LAST SUPPER"	XVI
COURTYARD OF A CANNON-FOUNDRY . . .	XVII
STUDY OF THE HEAD OF AN APOSTLE . . .	XVIII
STUDY FOR BACKGROUND OF "THE ADORATION OF THE MAGI"	XIX
STUDY OF LANDSCAPE	XX
STUDY OF A TREE	XXI
TWO HEADS. CARICATURES	XXII
ST. JOHN THE BAPTIST	XXIII
THE HEAD OF CHRIST	XXIV
CARICATURES	XXV
HEAD OF AN ANGEL	XXVI
STUDY OF A MAN'S HEAD	XXVII

LIST OF ILLUSTRATIONS

	PLATE
STUDIES OF HANDS	XXVIII
DRAGON FIGHTING WITH A LION	XXIX
MAN KNEELING	XXX
PORTRAIT STUDY	XXXI
STUDIES OF ANIMALS	XXXII
PORTRAIT OF LEONARDO, BY HIMSELF	XXXIII
SIX HEADS OF MEN AND A BUST OF A WOMAN	XXXIV
STUDY OF A HEAD	XXXV
THE ST. ANNE CARTOON	XXXVI
STUDIES OF HORSES	XXXVII
HEADS OF A WOMAN AND A CHILD	XXXVIII
STUDY OF DRAPERY FOR A KNEELING FIGURE	XXXIX
KNIGHT IN ARMOUR	XL
STUDY OF A YOUTHFUL HEAD	XLI
STUDY FOR "LEDA"	XLII
HEAD OF AN OLD MAN	XLIII
STUDY OF A HEAD	XLIV
STUDY OF THE HEAD OF ST. PHILIP FOR "THE LAST SUPPER"	XLV
STUDY OF DRAPERY	XLVI
GIRL'S HEAD	XLVII
STUDIES OF A SATYR WITH A LION	XLVIII

THE DRAWINGS OF LEONARDO DA VINCI
BY C. LEWIS HIND

LEONARDO DA VINCI found in drawing the readiest and most stimulating way of self-expression. The use of pen and crayon came to him as naturally as the monologue to an eager and egoistic talker. The outline designs in his "Treatise on Painting" aid and amplify the text with a force that is almost unknown in modern illustrated books. Open the pages at random. Here is a sketch showing "the greatest twist which a man can make in turning to look at himself behind." The accompanying text is hardly needed. The drawing supplies all that Leonardo wished to convey.

Unlike Velasquez, whose authentic drawings are almost negligible, pen, pencil, silver-point, or chalk were rarely absent from Leonardo's hand, and although, in face of the *Monna Lisa* and *The Virgin of the Rocks* and the *St. Anne*, it is an exaggeration to say that he would have been quite as highly esteemed had none of his work except the drawings been preserved, it is in the drawings that we realise the extent of "that continent called Leonardo." The inward-smiling women of the pictures, that have given Leonardo as painter a place apart in the painting hierarchy, appear again and again in the drawings. And in the domain of sculpture, where Leonardo also triumphed, although nothing modelled by his hand now remains, we read in Vasari of certain "heads of women smiling."

"His spirit was never at rest," says Antonio Billi, his earliest biographer, "his mind was ever devising new things." The restlessness of that profound and soaring mind is nowhere so evident as in the drawings and in the sketches that illustrate the manuscripts. Nature, in lavishing so many gifts upon him, perhaps withheld concentration, although it might be argued that, like the bee, he did not leave a flower until all the honey or nourishment he needed was withdrawn. He begins a drawing on a sheet of paper, his imagination darts and leaps, and the paper is soon covered with various

designs. Upon the margins of his manuscripts he jotted down pictorial ideas. Between the clauses of the "Codex Atlanticus" we find an early sketch for his lost picture of *Leda*.

The world at large to-day reverences him as a painter, but to Leonardo painting was but a section of the full circle of life. Everything that offered food to the vision or to the brain of man appealed to him. In the letter that he wrote to the Duke of Milan in 1482, offering his services, he sets forth, in detail, his qualifications in engineering and military science, in constructing buildings, in conducting water from one place to another, beginning with the clause, "I can construct bridges which are very light and strong and very portable." Not until the end of this long letter does he mention the fine arts, contenting himself with the brief statement, "I can further execute sculpture in marble, bronze, or clay, also in painting I can do as much as any one else, whoever he be." Astronomy, optics, physiology, geology, botany, he brought his mind to bear upon all. Indeed, he who undertakes to write upon Leonardo is dazed by the range of his activities. He was military engineer to Cæsar Borgia; he occupied himself with the construction of hydraulic works in Lombardy; he proposed to raise the Baptistery of San Giovanni at Florence; he schemed to connect the Loire by an immense canal with the Saône; he experimented with flying-machines; and his early biographers testify to his skill as a musician. Painting and modelling he regarded but as a moiety of his genius. He spared no labour over a creation that absorbed him. Matteo Bandello, a member of the convent of Santa Maria della Grazie, gives the following account of his method when engaged upon *The Last Supper*. "He was wont, as I myself have often seen, to mount the scaffolding early in the morning and work until the approach of night, and in the interest of painting he forgot both meat and drink. There came two, three, or even four days when he did not stir a hand, but spent an hour or two in contemplating his work, examining and criticising the figures. I have seen him, too, at noon, when the sun stood in the sign of Leo, leave the Corte Vecchia (in the centre of the town), where he was engaged on his equestrian statue, and go straight to Santa Maria della Grazie, mount the scaffolding, seize a brush, add two or three touches to a single figure, and return forthwith."

Leonardo impressed his contemporaries and touched their imaginations, even as he captivates us to-day. Benvenuto Cellini describes King Francis as hanging upon Leonardo's words during the last years of his life, and saying that "he did not believe that any other

man had come into the world who had attained so great a knowledge as Leonardo." Everybody knows Pater's luminously imaginative essay on Leonardo, and scientific criticism has said perhaps the last word upon his achievement in Mr. McCurdy's recent volume, and in Mr. Herbert P. Horne's edition of Vasari's "Life." As to the drawings, Mr. Bernhard Berenson, in his costly work on "The Drawings of the Florentine Masters," has included a *catalogue raisonné*, has scattered lovely reproductions through the pages, and placed his favourites on the pinnacle of his appreciation. In the manuscripts, with their wealth of sketches in the text, one realises the tremendous sweep of Leonardo's mental activity. Some are still unpublished, but the Italian Government promise a complete edition of the MSS. at an early date. His "Treatise on Painting" is easily accessible in Dr. Richter's "Literary Works of Leonardo da Vinci" —that wonderful treatise which begins: "The young student should, in the first place, acquire a knowledge of perspective, to enable him to give every object its proper dimensions: after which, it is requisite that he be under the care of an able master, to accustom him, by degrees, to a good style of drawing the parts. Next, he should study Nature, in order to confirm and fix in his mind the reason of those precepts which he has learnt. He must also bestow some time in viewing the works of various old masters, to form his eye and judgment, in order that he may be able to put in practice all that he has been taught." Chapter ccxxx. in the section on "Colours" is entitled "How to paint a Picture that will Last Almost for Ever." In view of the present condition of *The Last Supper* at Milan, fading from sight, Leonardo was wise to insert the word "almost." He is constantly giving the reader surprises, and not the least of them is the series of "Fables" from his pen, included in Dr. Richter's edition of his literary works.

One authentic portrait of Leonardo by his own hand exists—the red chalk drawing in the library at Turin. Dating from the last years of his life, it shows the face of a seer, moulded by incessant thought into firm, strongly marked lines. The eyes lurk deep beneath shaggy brows, the hair and beard are long and straggling— it is the face of a man who has peered into hidden things and who has pondered deeply over what he discerned. The beard is no longer "curled and well kept," in the words of a contemporary document, wherein he is described as "of a fine person, well proportioned, full of grace and of a beautiful aspect, wearing a rose-coloured tunic, short to the knee, although long garments were then in use."

Mr. Berenson has suggested that the youth in armour, who alone

among all the figures in Leonardo's *Adoration of the Magi* in the Louvre turns away from the scene and looks towards the spectator, is a portrait of Leonardo himself. Botticelli reproduced his own features in a figure similarly placed in his *Adoration of the Magi*.

The largest collection of Leonardo da Vinci's drawings is in the Royal Library at Windsor Castle. They are not accessible to the public in general, but under certain conditions they may be examined. Other collections are in the Louvre, the British Museum, the Uffizi, the Royal Library at Turin, the Venice Academy, and in the portfolios of private collectors such as M. Bonnat of Paris, and Dr. Mond of London. The drawings in the Print Room of the British Museum, which are easily available to students, include the remarkable *Head of a Warrior* in profile, from the Malcolm Collection, which is reproduced in this volume. This beautiful and minutely finished head and bust in silver-point belongs to Leonardo's early period, when he was still under the influence of his master, Verrocchio. Indeed, there is a resemblance between this arrogant warrior and the head of Verrocchio's statue of Colleoni at Venice; it has been suggested by Dr. Gronau that this profile represents an effort of the pupil to show Verrocchio the manner in which he would have handled the task. Be that as it may, this drawing is a striking example of how, in the hands of a master, the most profuse and detailed decoration can be made subservient to the main theme. The eye follows with delight the exquisite imaginative drawing in armour and helm. Nothing is insistent; nothing is superfluous. Every quaint and curious detail leads up to the firm contour of the face. Leonardo saw the theme as a whole, and the decorator's ingenuity has throughout remained subservient to the artist's vision. It is War quiescent, as Rodin's famous group is War militant. The British Museum also contains a sheet of those grotesque heads, specimens of which are reproduced in this volume, horrible faces of men and women grimacing and screeching at one another, with protruding lips and beak-like chins, looming from the discoloured paper. In a drawing at Milan there are two sketches of a combat, a man on horseback fighting a grotesque animal, that are startling in their power of arrested movement. There are also drawings of fearful wild-fowl, dragons, and the like, snarling at one another and making frightful onslaught. Critics have tried to explain the reason why Leonardo gazed into these gulfs, but the explanation is probably nothing more than the fertility and fecundity of his imagination. The grotesque and the terrible often have an attraction for gifted minds, forming a relief from the endless quest after beauty and the

THE DRAWINGS OF LEONARDO DA VINCI

physical strain of living continually on the heights. Rossetti composed verses that are not included in his collected works. A distinguished living writer has confessed that the byways of his leisure are brightened by the study of criminology. The late Arthur Strong, commenting on the grotesques by Leonardo da Vinci at Chatsworth, contributes this curious and interesting theory: "His method was akin to the geometry of projection. Just as the shadow of a circle is an ellipse, so by projecting the lines of a human face of a certain marked type he was enabled to detect and exhibit, as in a shadow, the secret but most real kinship between the *bête humaine* and the dog, the ape, or the swine, as the case might be. In a sheet of drawings at Windsor we see the same process applied to the head of a lion until it quickens into a lower canine form."

The late librarian of Chatsworth also comments upon the copies and forgeries of drawings by Leonardo da Vinci that abound at Chatsworth, as in other collections. The process of sifting the pictures ascribed to Leonardo may be said to be complete. John William Brown, in the Appendix to his life of Leonardo, published in 1828, catalogues nearly fifty pictures from the hand of the master. Mr. McCurdy, in his study of the records of Leonardo's life, has reduced that generous estimate to ten. There is still considerable disagreement about some of the drawings, but there are enough indubitably authentic, a bewildering variety indeed, for all practical purposes of study, and to proclaim the abounding genius of this flame-like Florentine, whose mind was a universe and who "painted little but drew much" with "that wonderful left hand." The fact that Leonardo was left-handed, with the result that the shading of his drawings usually runs from left to right, and not from right to left, should be evidence, as Morelli and others have pointed out, of the authenticity of those drawings whose lines of direction run from left to right. But this test is far from perfect, as it is the first business of a forger to study mannerisms. Many of the drawings bear comments in his handwriting, which also usually ran from right to left, the famous letter to the Duke of Milan being an exception. A pen-drawing in the Uffizi has, in the lower part, a note from which the beginning has been torn away. The words that remain are: ". . . bre 1478 ichomiciai le 2 Vgine Marie," which may be interpreted, "October 1478, I began the two of the Virgin Mary."

Most of the drawings are made with the pen, others are in chalk and silver-point. In the well-known *Isabella d'Este* of the Louvre there are traces of pastel, and some of the sketches of drapery are drawn on fine linen with a brush.

THE DRAWINGS OF LEONARDO DA VINCI

One of Leonardo's earliest drawings, if not his first attempt, is the landscape dated 1473 in the Uffizi, done when he was twenty-one years of age. It is signed, and these words are inscribed in the left-hand top corner: "The day of S. Mary of the Snow, the fifth day of August, 1473."

Another drawing that can be assigned to a period is the sketch in pen and ink of a youth hanging from a rope with his hands fastened behind his back. This unfortunate was Bernardo Bandini, who was hanged for the murder of Giuliano de Medici in 1479. It is supposed that Leonardo was commissioned to paint a picture of the execution, and that he made the drawing of Bandini as a preparatory study. Leonardo was nothing if not conscientious. On the margin of the sketch, which is in the possession of M. Bonnat, is this note describing Bandini's costume: "Small tan-coloured cap, black satin doublet, lined black jerkin, blue coat lined with fur of foxes' breasts, and the collar of the cloak covered with velvet speckled black and red; Bernardo di Bandino Baroncelli; black hose."

As we turn over and examine the diversified drawings by Leonardo da Vinci, we are continually reminded of the passion that draughtsmanship was to him. Pen and pencil bear witness that his mind was never at rest. He drew for the love of it; his hand raced to obey the thronging pictures that his brain conceived, and he drew, not necessarily as a preparatory stage for the making of a picture, but because draw he must. Despite the hundreds of drawings that remain as examples of his industry, there are no studies extant for the *Monna Lisa*, although it has been suggested that the hands from the Windsor Collection reproduced in this volume were preparatory sketches for the marvellous hands of that third wife of a Florentine official upon whose head all "the ends of the world are come." Critics differ on this point, but there is no difference of opinion as to the beauty of Monna Lisa's hands. "The right hand," says Mr. McCurdy, "is perhaps the most perfect hand that was ever painted."

Probably many of the sheets of drawings of children, women, cats, and lambs were for Madonna pictures that have been lost or destroyed. He was never content with the stereotyped and conventional arrangement for a sacred picture, such as satisfied Francia. He was ever curious, as well as a seeker after beauty, and life being his province, he loved to intrigue the human element into a Madonna and Child motive. The Child playing with the cat, hugging a lamb, learning his lessons at his mother's knee, numbers of them testify to Leonardo's direct and large-hearted humanity. With him

the Child is always a child, acting like a child. In a drawing in the British Museum he clutches a protesting cat in his chubby arms, while the mother smiles—the eternal, personal smile of Leonardo that haunted him, as it fascinates us. In another drawing the Child is dipping a chubby hand into a bowl of porridge, and again the Mother smiles—the enigmatic, persisting smile of Leonardo. There are no fewer than twenty-seven drawings of animals on one sheet at Windsor. The majority are cats, but in some instance his imagination has invented a hybrid animal to which no name can be given. In a drawing at Milan the Child is apparently receiving a lesson in geometry—one of Leonardo's special studies. "He is entirely wrapped up in geometry, and has no patience for painting," writes a correspondent to Isabella d'Este in reply to a letter from her asking what Leonardo was doing. "Since he has been in Florence," continues the correspondent, "he has worked only on one cartoon. This represents an infant Christ of about one year, who, freeing himself from his mother's arms, seizes a lamb, and seems to clasp it."

There is no record that these pictures of the Child with cat or lamb, or dropping his hand into a bowl of porridge, were ever finished; but the drawings were seen by the young Raphael, who drew inspiration from them. It is curious to turn from these imaginative designs to the literal study of a tree, searched out as carefully as Leighton's drawing of a lemon-tree, but so much bolder and so much more confident in treatment; or to that drawing that might have been produced in an engineer's office, showing a number of nude figures lifting a heavy cylinder by lever-power, probably a design dating from the period when he held the post of military engineer to Cæsar Borgia. During his residence at Pavia, when, among other activities, he constructed the scenery for a kind of masque produced in honour of the marriage of Gian Galeazzo with Isabella of Aragon, and on another occasion arranged a tournament, he also designed an apparatus of pulleys and cords to convey the relic of the Sacred Nail to a different position in the Cathedral. The sketch is inscribed, "In the Cathedral for the pulley of the Nail of the Cross."

Moderns who try to paint without first undergoing the drudgery of drawing for some years in the schools should ponder over Leonardo's studies of the nude, reading at the same time the chapters on "Proportion" in his "Treatise on Painting." What wholehearted pre-occupation in his work the following extract shows! It is entitled "Of studying in the Dark, on first waking in the Morning, and before going to Sleep." "I have experienced no small benefit,

when in the dark and in bed, by retracing in my mind the outlines of those forms which I had previously studied, particularly such as had appeared the most difficult to comprehend and retain; by this method they will be confirmed and treasured upon the memory."

Flowers, trees, and wings he studied with the same fidelity and felicity that he gave to hands and drapery. He was for ever preparing and experimenting, for ever storing and developing his mind, for ever increasing the cunning of his hands, as if life were endless. His sixty-seven years of activity were all too short for this giant, who excelled in every worthy pursuit of mortals except commerce and politics. A Florentine poet of the Quattrocento, who knew Leonardo in his early manhood, described him as the man who "perhaps excels all others, yet cannot tear himself away from a picture, and in many years scarce brings one to completion." His mind was continually putting forth fresh shoots. We can imagine him, before beginning to paint the wings of the angel in his picture of *The Annunciation* in the Louvre, studying the ways of birds at rest and in flight, and considering the problem of the possibility of man ever achieving the conquest of the air. Such ideas never came to fruition, but there is a passage in his writings, written in a moment of exaltation, when he had vision of man floating on pinions in the ether, and himself as inventor and originator of the triumph. In that moment of vision of a perfected Santos-Dumont, Leonardo wrote: "He will fill the universe with wonder and all writings with his fame, and will give deathless renown to the nest which witnessed his birth."

Through all his dreams, through all his scientific, human, and grotesque imaginings, he never ceased from the quest of beauty, that obsession of the true artist, which he expressed so often in the faces of his women, their hair and hands, in the looks of children, in the fall and fold of draperies, and in the figures of armed knights setting forth to tourney or to battle. One only has to recall the face of St. Anne in the Louvre picture, the curling, plaited hair about the head of Leda in the Windsor drawing, the strange sexless charm of the smile of St. John the Baptist in the Louvre picture, *Monna Lisa*, the "sceptical" angel in *The Virgin of the Rocks*, and the head of St. Philip in the Windsor drawing, to be impressed again by the enigmatic beauty, always new, never palling, that Leonardo gave to the world. In the cartoon of the *Virgin and Child with St. Anne* which hangs in the Diploma Gallery at Burlington House, one of the nation's greatest treasures, which so few Londoners ever visit, this country possesses a characteristic and unapproachable Leonardo.

It differs materially from the picture in the Louvre, the heads of the Virgin and St. Anne being nearly on a level; St. Anne is gazing at the Virgin, not at the Child, her hand is upraised, the finger points upwards, and the Baptist is included in the composition. But in each the face of St. Anne has the Leonardo inward, extenuating smile, suggesting that attribute of aloofness of which the mediæval schoolmen write. The upward-pointing hand of St. Anne is almost identical with the motion of St. Thomas's hand in *The Last Supper* at Milan, and with the hand of St. John in the Louvre. Comparing the Diploma Gallery cartoon with the finished picture in the Louvre, and with the sketch at the Venice Academy, we realise the years of labour that Leonardo gave to a picture before he would call it finished. One of the drawings of drapery reproduced in this volume is an exquisite study for the garment that enfolds the Virgin's limbs in the Louvre picture.

The series of heads of women reproduced in these pages show again his love of hair, either flowing or in plaits, or confined in strange and delicate head-dresses about the sweet, severe brows. And always the eyes of his women are cast down, an attitude that he rarely gives to his men, whose heads often have a touch of caricature, a hint, but never pushed to the extreme that he allowed himself in the grotesque.

In the bust of a woman in profile at Milan we have a sketch that in the unflattering presentment of a likeness is akin to his remarkable drawing of Isabella d'Este, now in the Louvre. The firm contour of the face, the thin nose and round, protruding chin, the long neck and ample bosom, betoken that on this occasion his eye, not his imagination, held the mastery. But the drawing of Isabella d'Este is larger in conception, and this grave and simple presentment of a distinguished lady of the Italian Renaissance is so informed with an assured power that it is justly hailed as one of Leonardo's finest efforts. It was made at Mantua, and was designed to serve as the study for the portrait of the Marchioness which Leonardo never completed, if indeed he ever began it. Five years later Isabella d'Este wrote to Leonardo reproaching him for his delay: " When you were in the country and drew our portrait in chalk you promised you would one day paint our picture in colours." But Leonardo was not, like Mantegna, ductile in the hands of the Marchioness. He did not succumb to her blandishments. There is no record that he ever gratified the lady by painting a certain small work that she made petition for—" a little picture of the Madonna full of faith and sweetness, just as his nature would enable him to

conceive her." Leonardo had pursuits more engrossing than the making of a picture to please the vanity even of so great a lady as the Marchioness of Mantua.

The flame of Leonardo's imagination did not burn with the desire to provide little pictures of the Madonna full of faith and sweetness. He must do things in his own way, and that way would inspire him to produce such a drawing as the head of a young Bacchus with long, curling hair, clothed in a costume, just peeping from the sketch, of a similar material to the dress of Isabella d'Este; or a kneeling Leda, such a drawing as we find at Chatsworth, showing how the artist gradually evolved the design for the final picture of *Leda*, which was seen in the collection of King Francis at Fontainebleau, but is now lost. Here, too, the eyes of the woman are downcast. She turns to the children who are breaking from the eggs, while one of her arms clasps the swan. The broken shells, and the children just scrambling into existence, are as characteristic of Leonardo's passion for the episodes of life as the Child playing with the cat, or dipping his fist into the bowl of porridge. *Leda* is the only mythological picture that he painted. The preparatory drawings, like the drawings for others of his lost or destroyed works, such as the *Sforza Statue*, and the *Battle of the Standard* are numerous. There is no mistaking the drawings for the Sforza statue, although it is not easy to decide which of the many designs of equestrian figures were for the Statue of Francesco Sforza, and which for the Trivulzio Monument. One of the Windsor drawings shows no fewer than four sketches on one sheet for the group of horse and rider, which, we are told, was twenty-six feet high. It would seem that Leonardo's first intention was to make Francesco Sforza's charger trampling on a fallen enemy, but that he abandoned this tremendous conception for a quieter design. It is clear from contemporary records that Leonardo spent sixteen years over the statue: to-day no trace of it, except in the drawings, remains. There is some doubt as to whether it was ever successfully cast in bronze, which explains Michael Angelo's taunt that after Leonardo had finished the model he was unable to cast it. Probably it was Leonardo's model that was destroyed, or at any rate severely damaged, when the French entered Milan in 1500. Fra Sabba da Castiglione wrote at the time: "I have to record—and I cannot speak of it without grief and indignation—so noble and masterly a work made a target by the Gascon bowmen."

In his writings Leonardo describes war as a "bestial frenzy," and in this grand conception of a rearing horse trampling upon a warrior,

who is trying to protect himself with his shield, it was perhaps his intention to pillory the horror of war, while at the same time producing a heroic design. The splendid vigour of this group, and of the maddened figures in the *Battle of Anghiari*, stimulate us even in the slight sketches. We hear the shouts of barbaric warfare as we draw them from their quiet resting-places in orderly portfolios. The " bestial frenzy " of war was never depicted with greater force than in Leonardo's studies for the last *Cartoon for the Battle of Anghiari*, where horses gnash at each other, and soldiers, filled with the lust of war, scream incoherent cries. The heads of two men in a drawing in the Buda-Pest Gallery, in the very act of slaying, mouths wide open, breathing fury, are almost painful to look upon. Leonardo abandoned this battle picture while still in the midst of the task, as if disgusted with continuing to portray the " bestial frenzy." But the horses in the battle pictures probably interested him. There is a galloping horse in a drawing of *Horsemen and Soldiers* at Windsor that reveals a marvellous knowledge of the action of the horse at high speed. Indeed, the horse was one of Leonardo's favourite subjects. Vasari states that a book of such studies was destroyed when the French entered Milan. In the large and minute drawing that he made as a preparatory study for the background of his picture of *The Adoration of the Magi*, which was changed and curtailed so much in the final composition, there are horses, curvetting and prancing, and in the foreground a camel is seen reposing. Actuality is introduced in the persons of the retainers of the kings, busy with their own affairs, amusing their leisure with a mock combat. In the drawing in the Uffizi, of which we give a reproduction, the retainers are shown below the great double staircase engaged in a joust. One wonders if Velasquez, who did not reach his usual standard of perfection when he drew a prancing steed, ever saw any of Leonardo's drawings of resolute and spirited horses.

Velasquez, when he painted the head of Christ in his *Crucifixion* at Madrid, veiled the face with the long hair as if he shrank from attempting to portray the sacred features, although nothing deterred him from painting the head boldly and freely in his *Christ at the Column*. History tells of a similar meticulous modesty on the part of Leonardo in regard to the head of the central figure in his *Last Supper*, which he left unfinished, on the suggestion of Zenale, that could not surpass the majesty of certain of the Apostles' heads.

Several preliminary studies for *The Last Supper* exist, many of which modern criticism refuses to accept as authentic. The most prominent in the eye of the world is the pastel of the head of Christ

in the Brera at Milan. Of the beauty of the head, feminine in its softness and sadness, there cannot be two opinions, but it has not the sense of virility of the head in the Milan fresco, although the pose of the drooping face and the downcast eyes are identical. The authorities of the Brera Gallery at Milan assign the pastel head to Leonardo, and Dr. Richter describes it as " a genuine half-life size study in pencil for a head of Christ, which is in a deplorable state of preservation." In Mr. McCurdy's opinion, the Brera pastel " in its present state is none of his, whatever its inception may have been, and of that it is impossible to judge." But whatever vicissitudes of retouching the Brera pastel may have undergone, it remains a beautiful thing. The full-sized heads at Weimar, bold and inspiring drawings, of Judas and St. Peter, St. Thomas and St. James the Elder, St. Andrew, and St. Bartholomew are not by Leonardo.

There is no doubt about the authenticity of the heads of the Apostles in the Windsor Collection, or of the two preparatory sketches for the composition of *The Last Supper* also at Windsor, or of the drawing in red chalk at Venice, containing Leonardo's handwriting, in which the figure of St. John is shown grief-stricken, his body thrown forward upon the table, his face hidden at the mere idea of the awful words, " One of you shall betray me."

Leonardo's will, executed on April 23, 1519, in the château of Cloux, near Amboise, is extant. He commends his soul to God, orders the celebration of four high masses and thirty low masses, and wills his vineyard, without the walls of Milan, to Salai and Battista de Villanis. In taking leave of this restless, richly endowed and rare spirit, we turn again to the last lines of Pater's essay, and with him wonder how the great Florentine " experienced the last curiosity." Then, perhaps, for the mind is always alert when thinking of Leonardo, we recall a note in one of his manuscripts wherein he expresses his conviction that some day with the help of steam a boat may be set in motion, and another passage in his handwriting, perhaps really nearer to his real self than the order for those four high and thirty low masses—this : " When I thought I was learning to live, I was but learning to die."

ILLUSTRATIONS

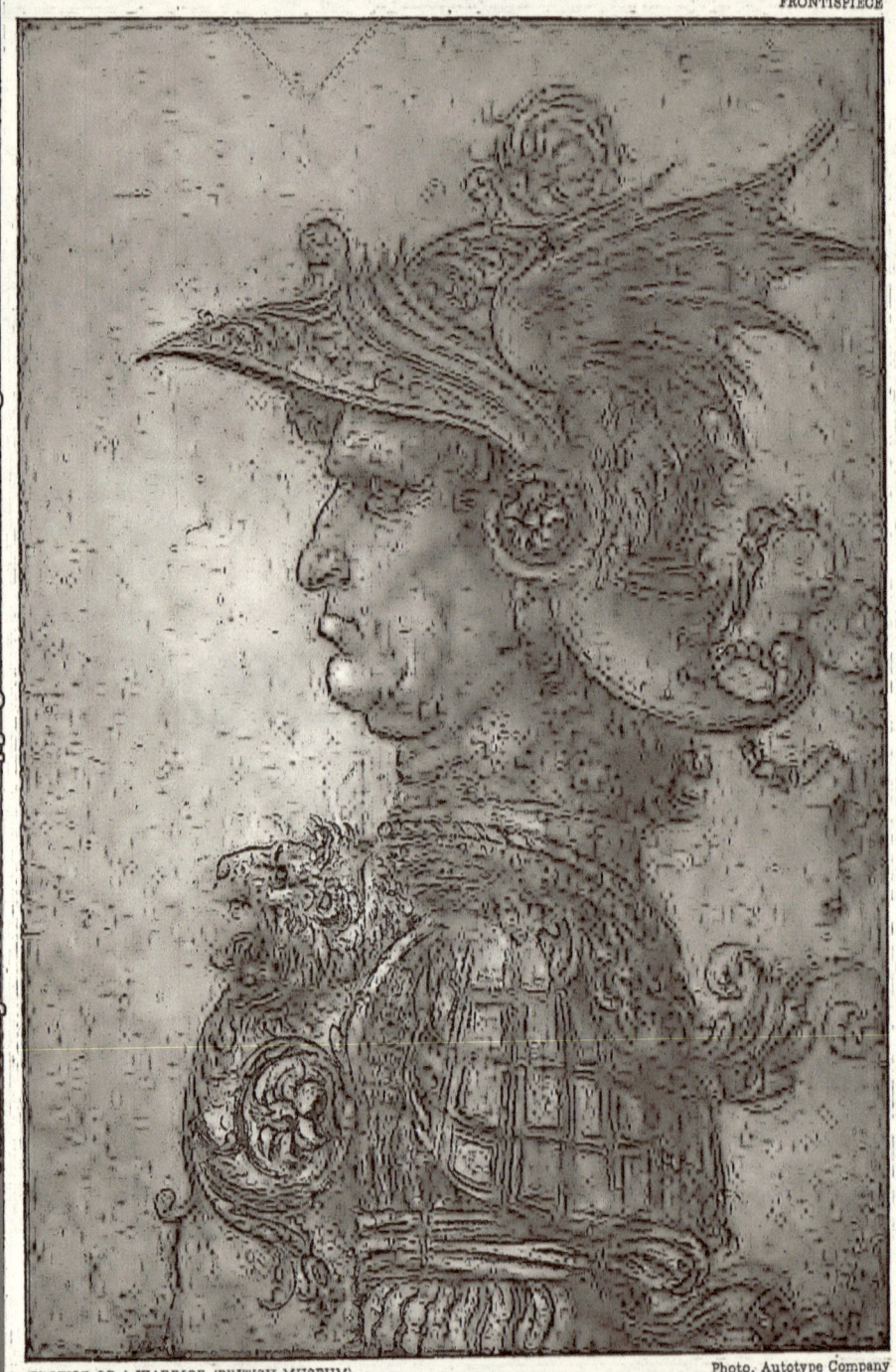

PROFILE OF A WARRIOR (BRITISH MUSEUM)

FRONTISPIECE

Photo, Autotype Company

PLATE I

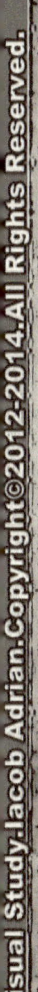

PORTRAIT OF ISABELLA D'ESTE (LOUVRE)

PHOTO, BRAUN, CLÉMENT

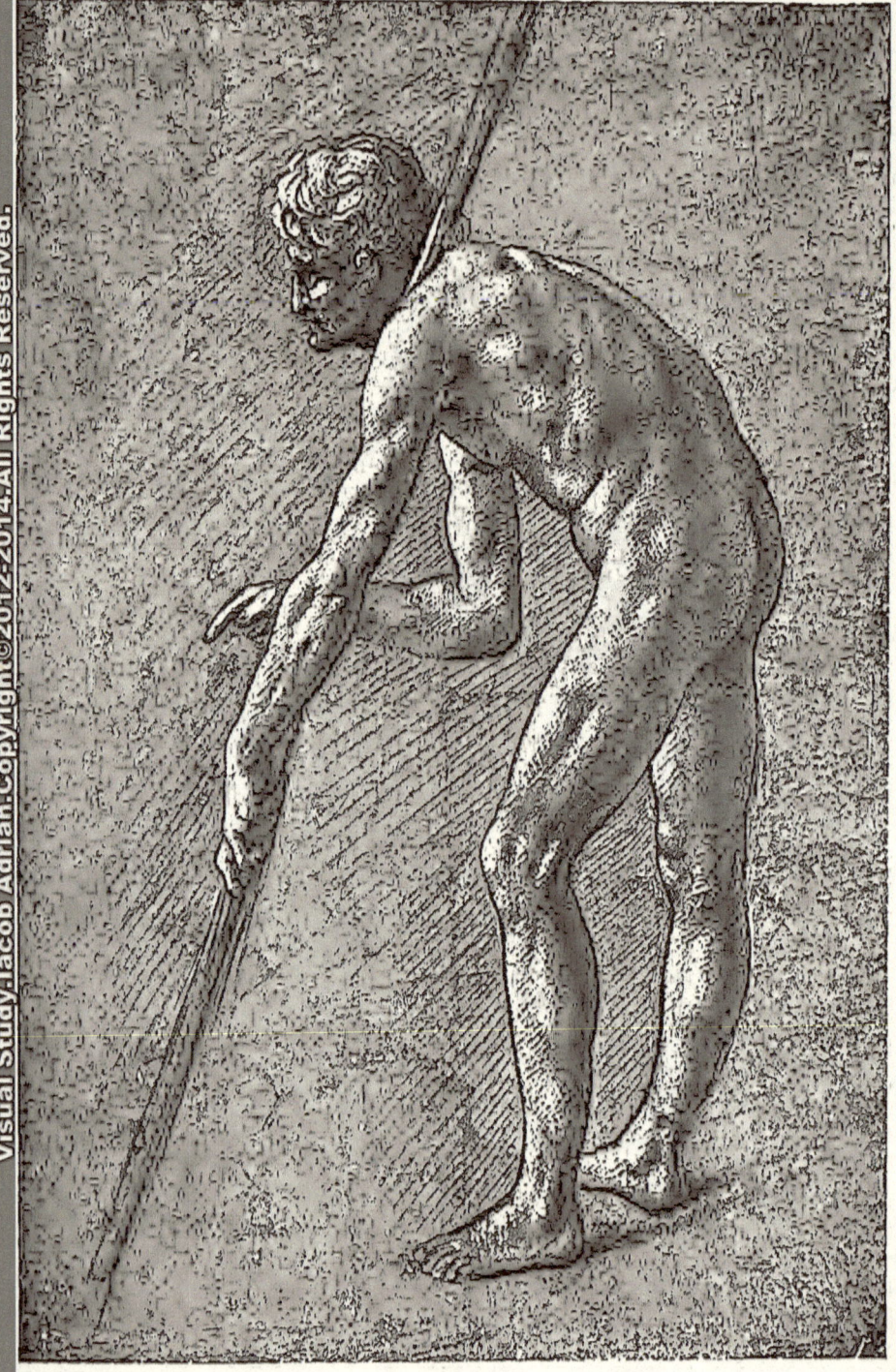

STUDY OF AN OLD MAN (MILAN) PHOTO, BRAUN, CLÉMENT

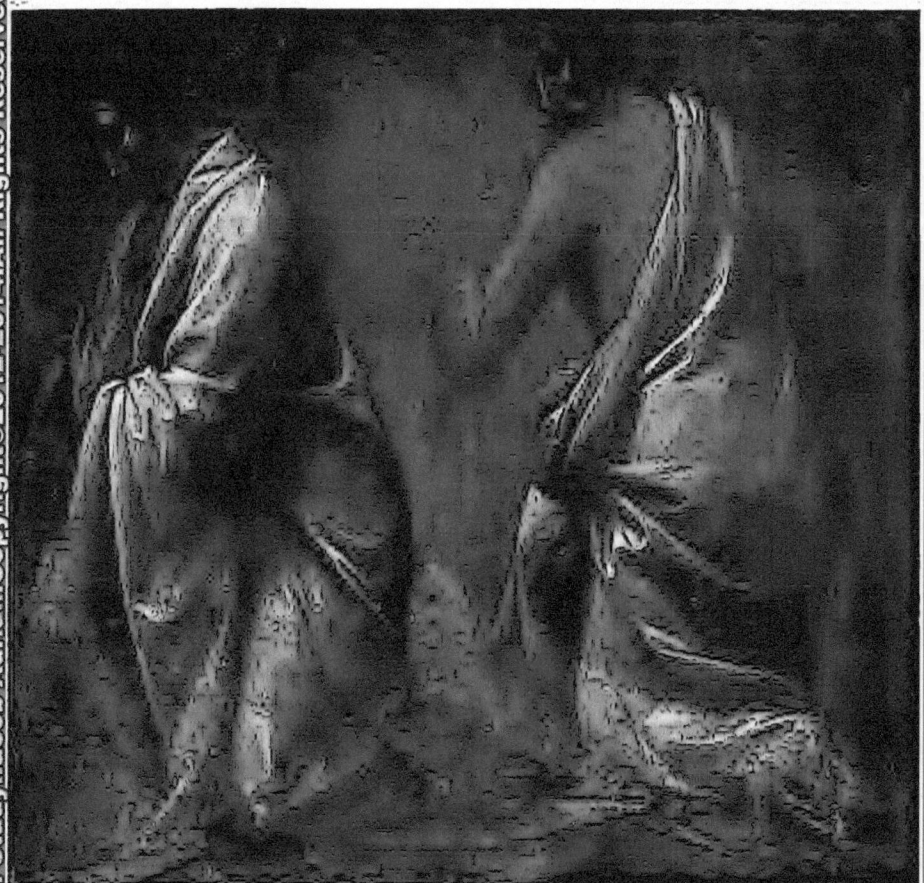

STUDY OF DRAPERIES FOR KNEELING FIGURES
(BRITISH MUSEUM)

PHOTO, AUTOTYPE COMPANY

PLATE III

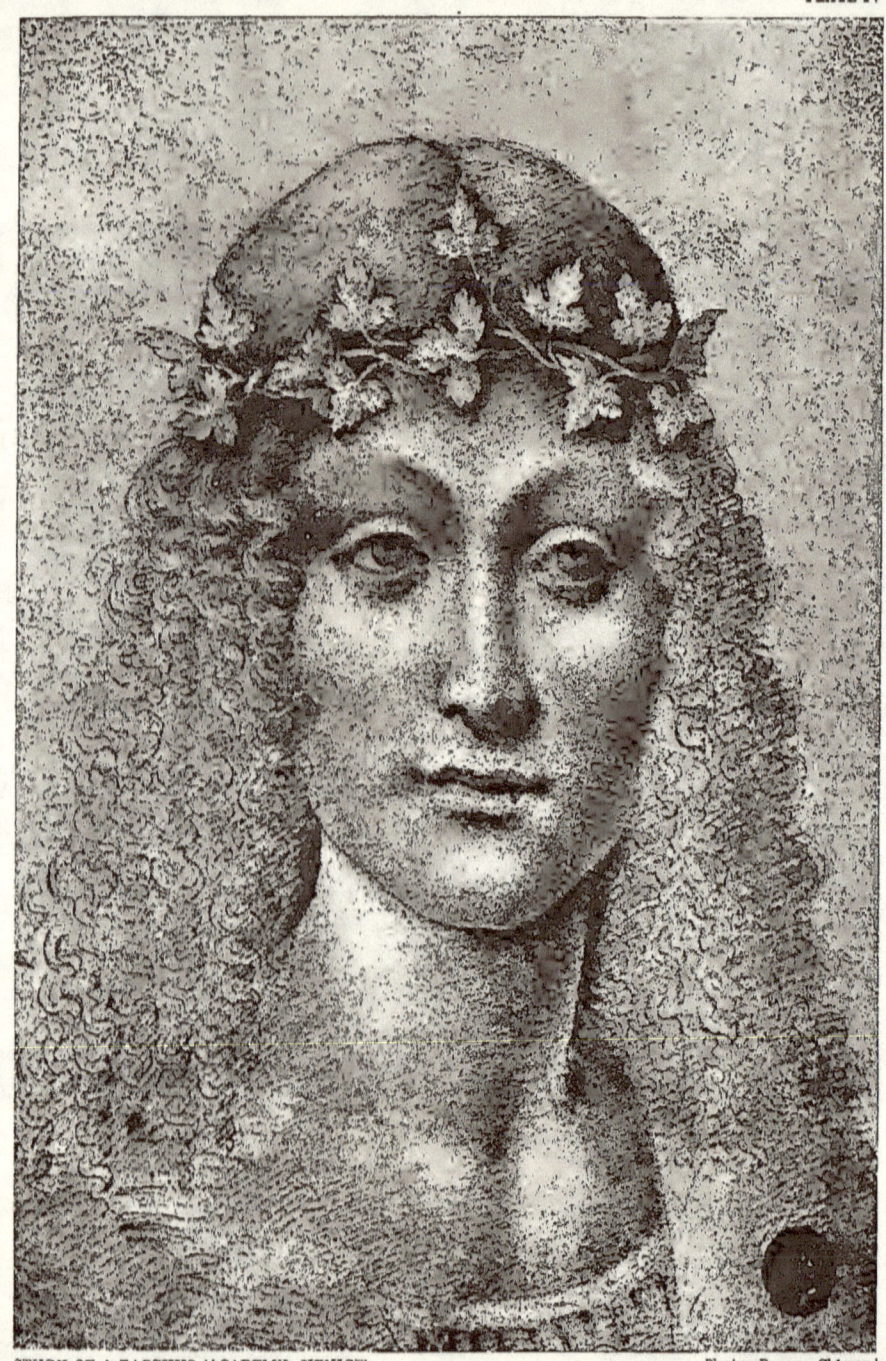

STUDY OF A BACCHUS (ACADEMY, VENICE) Photo, Braun, Clément

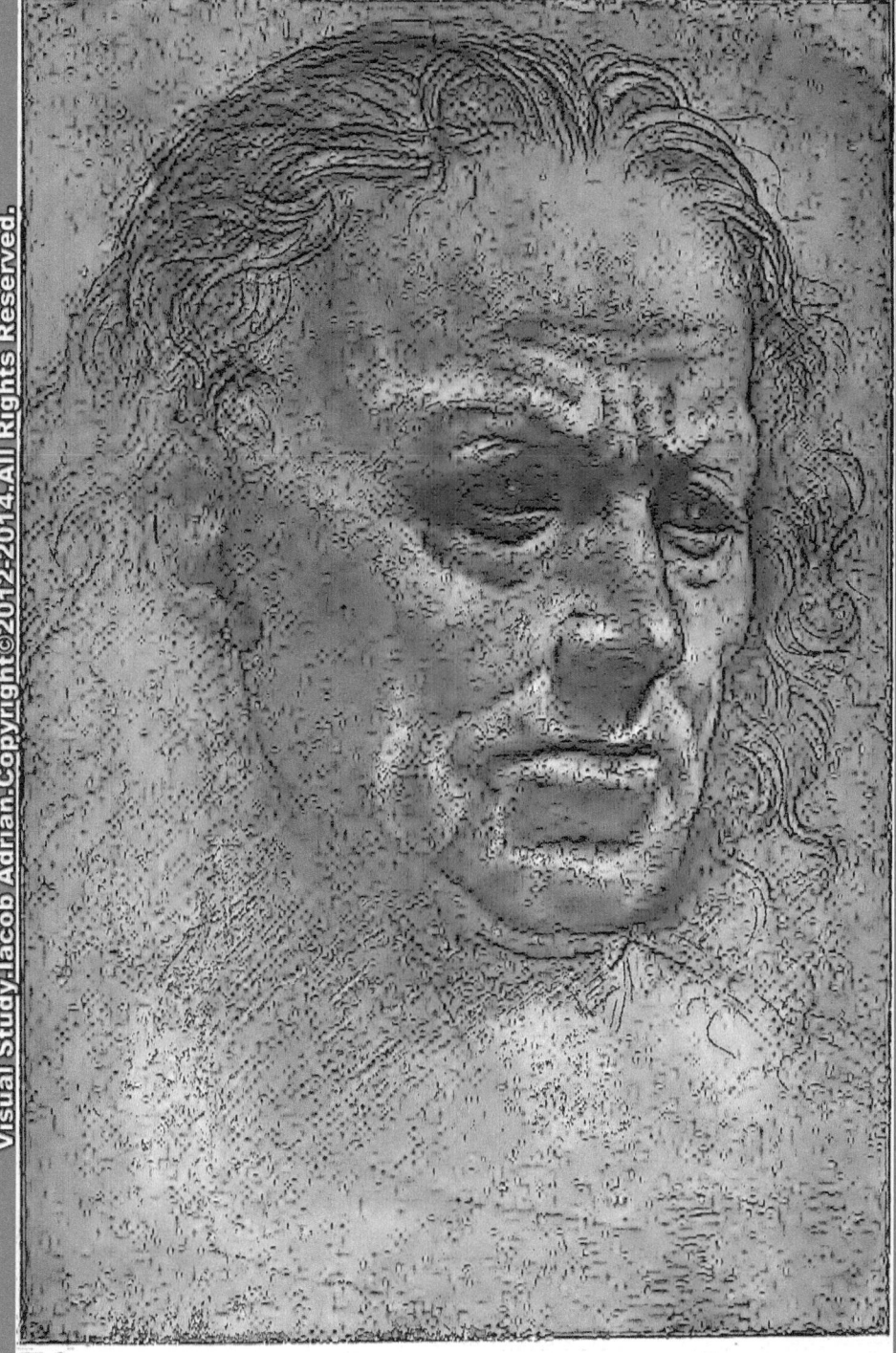

HEAD OF A MAN (LOUVRE)

PLATE VI

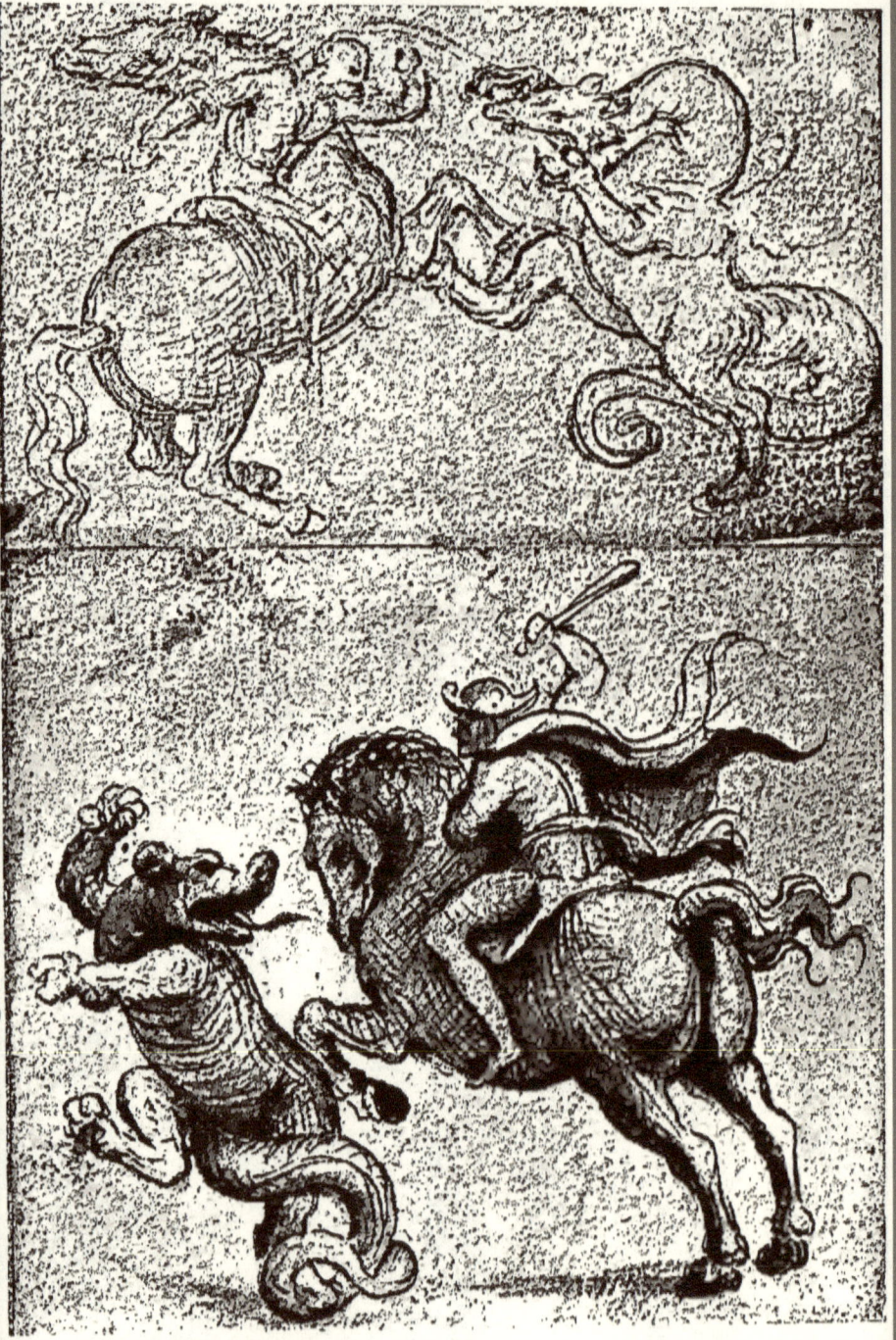

BATTLE BETWEEN HORSEMEN
AND MONSTERS (MILAN)

PHOTO, BRAUN, CLÉMENT

PLATE VII

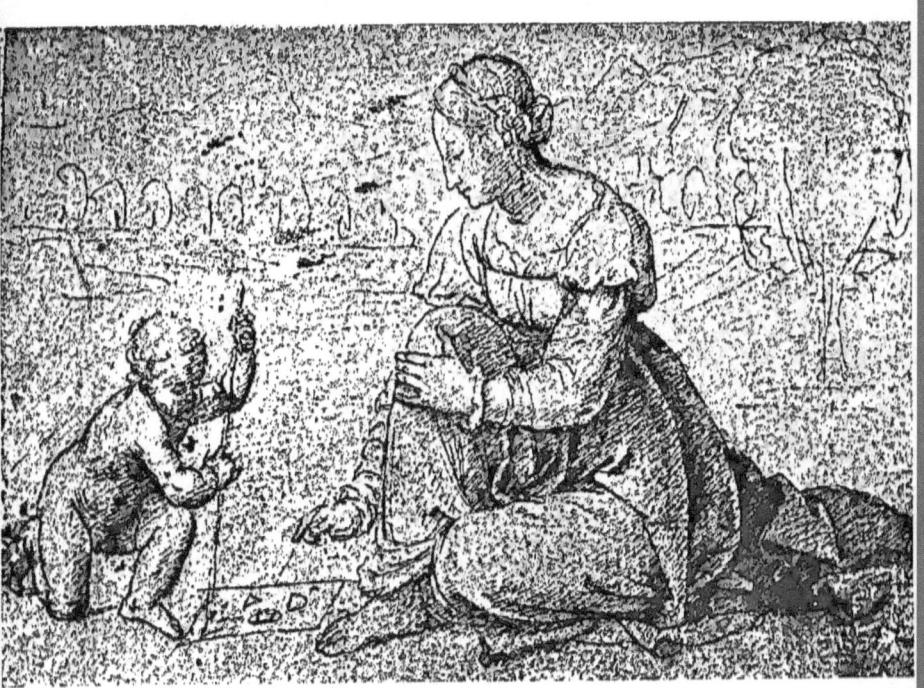

WOMAN SEATED ON GROUND AND A CHILD KNEELING (MILAN)

PHOTO, BRAUN, CLÉMENT

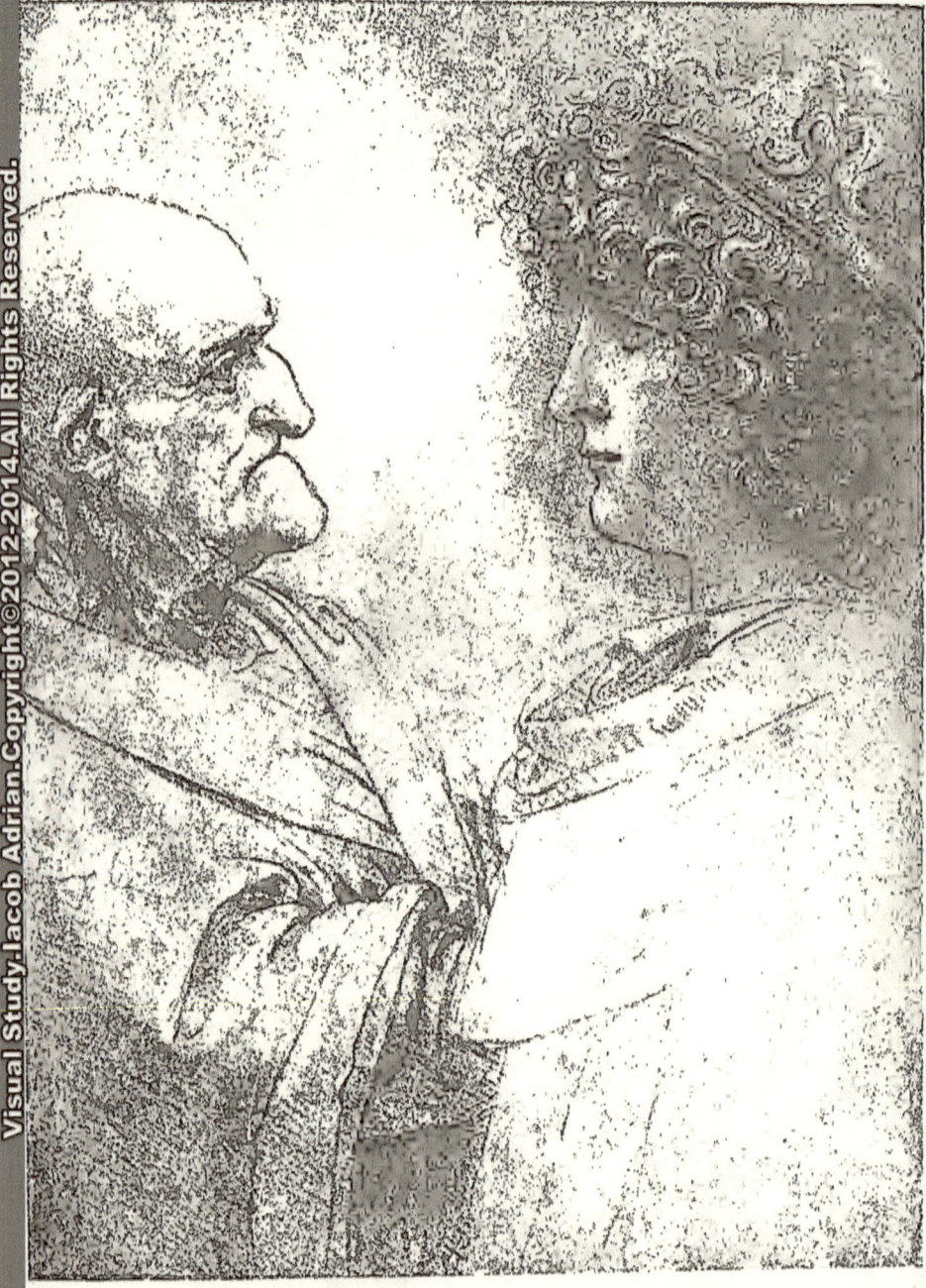

STUDIES OF HEADS (UFFIZI, FLORENCE)

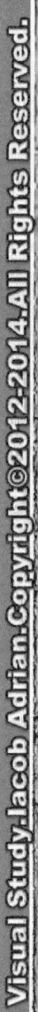

PLATE IX

YOUTH ON HORSEBACK (WINDSOR)

PHOTO, BRAUN, CLÉMENT

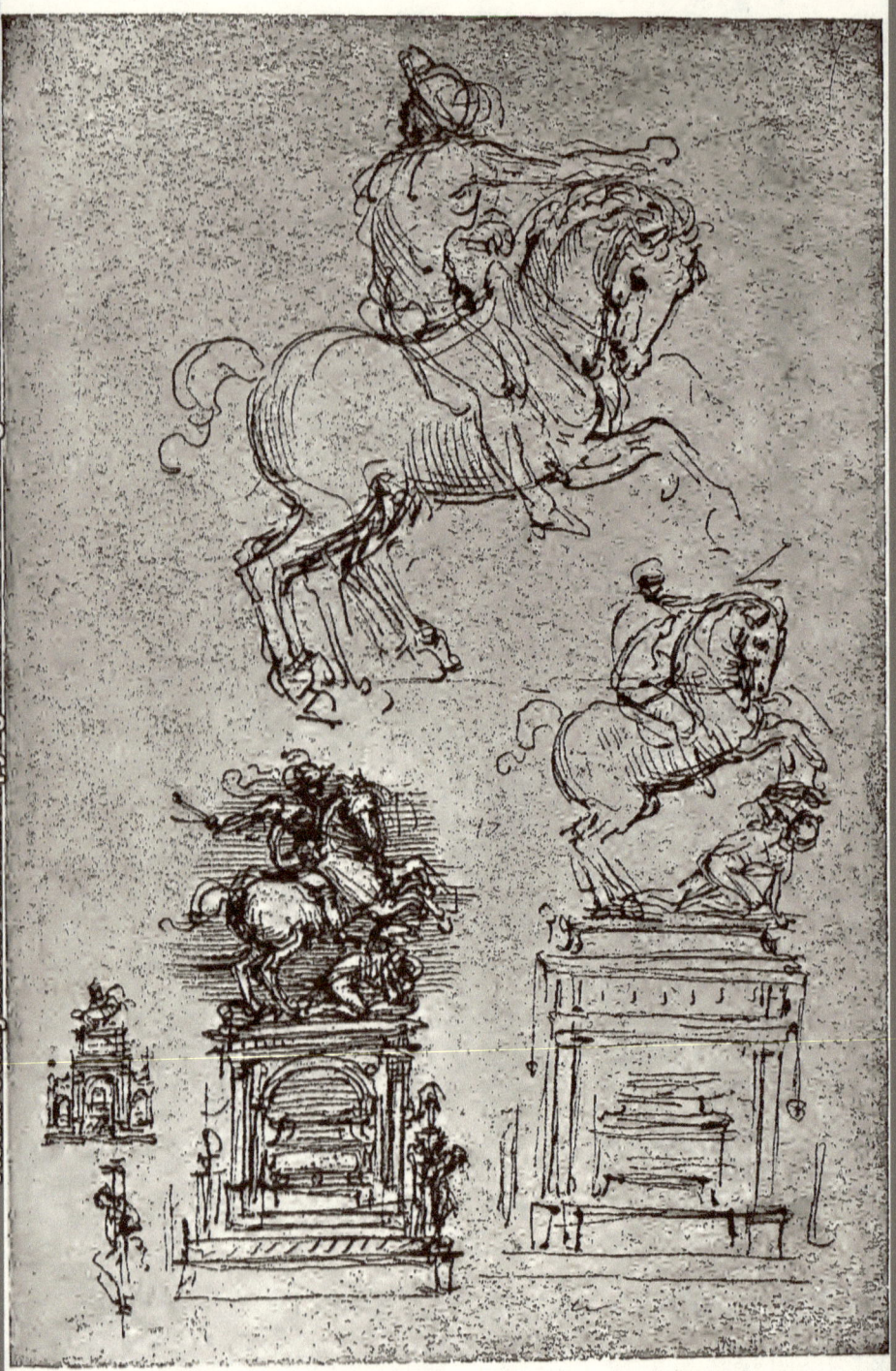

STUDIES FOR THE EQUESTRIAN STATUE
OF FRANCESCO SFORZA (WINDSOR)

PLATE XI

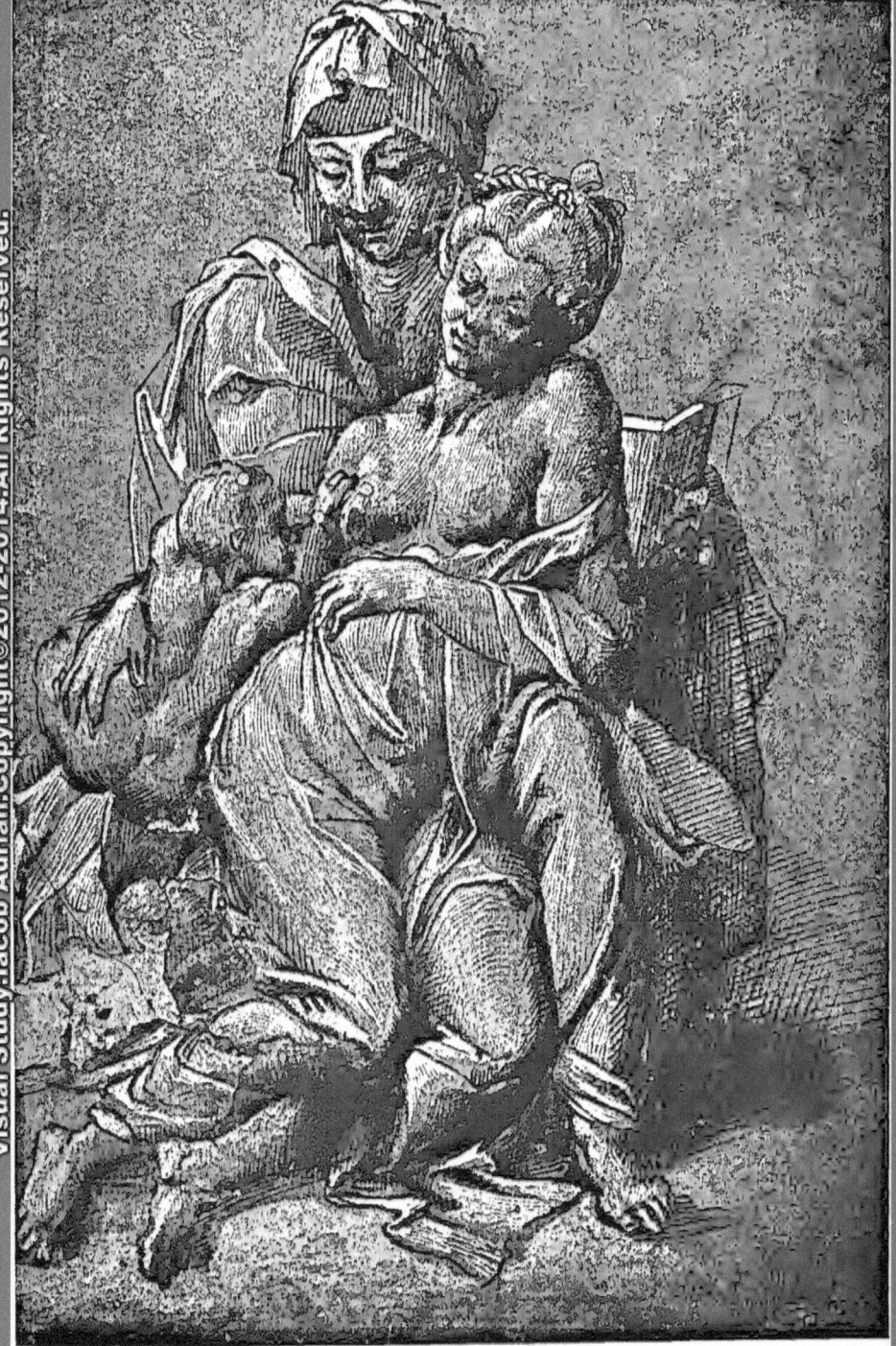

THE VIRGIN, ST. ANNE AND INFANT (LOUVRE) PHOTO, BRAUN, CLÉMENT

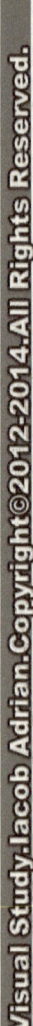

PLATE XII

STUDIES OF CHILDREN (CHANTILLY)

PHOTO, BRAUN, CLÉMENT

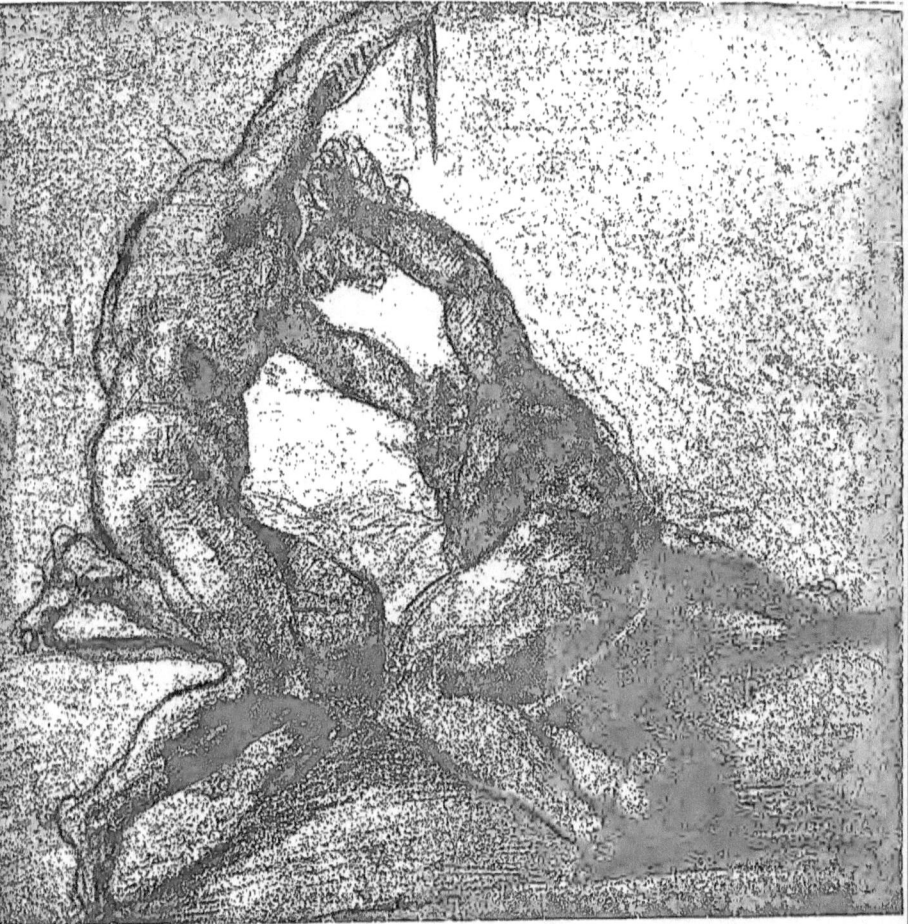

THE COMBAT (LOUVRE)

PHOTO, BRAUN, CLÉMENT

PLATE XIV

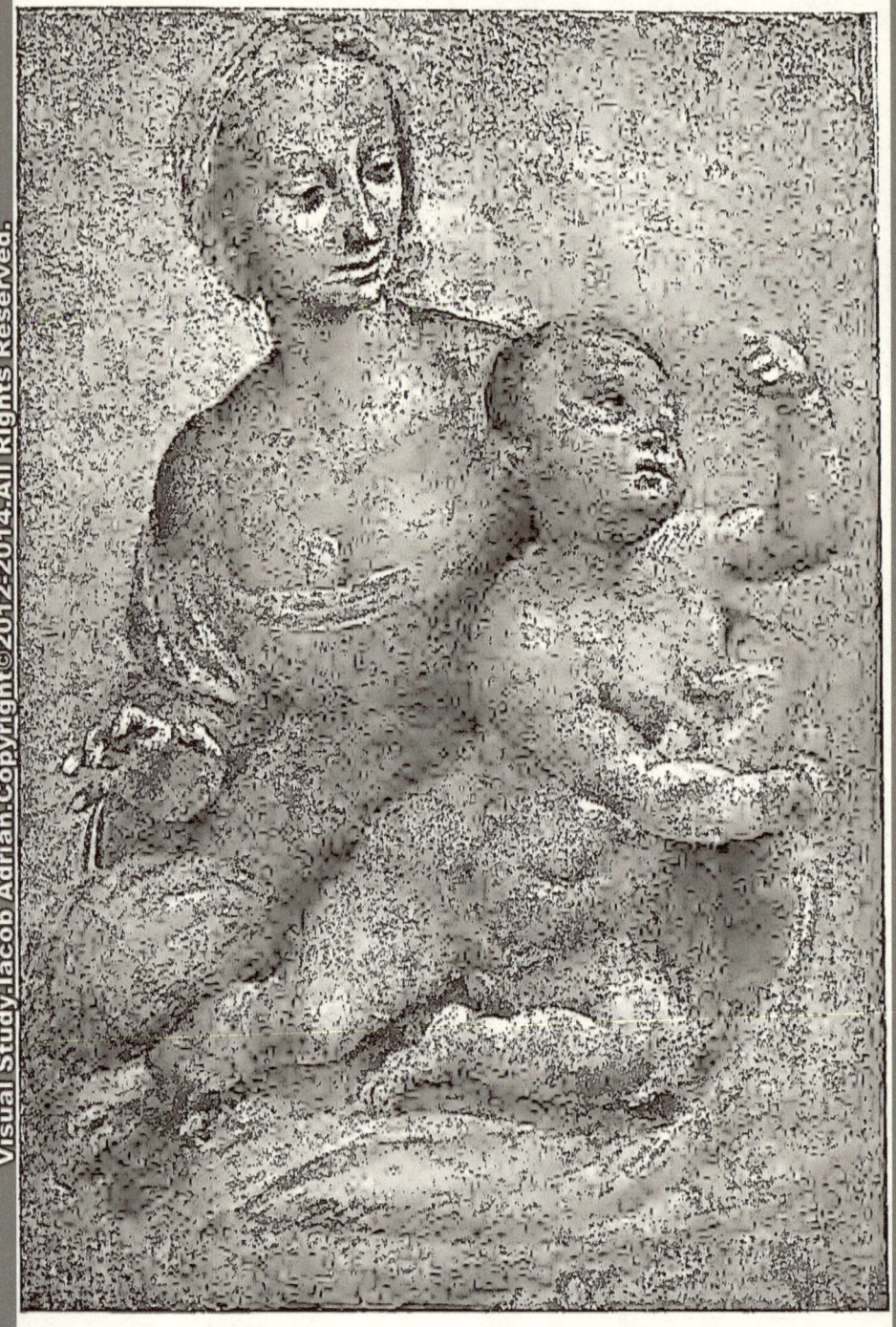

STUDY FOR A MADONNA
(UFFIZI, FLORENCE)

PHOTO, BRAUN, CLÉMENT

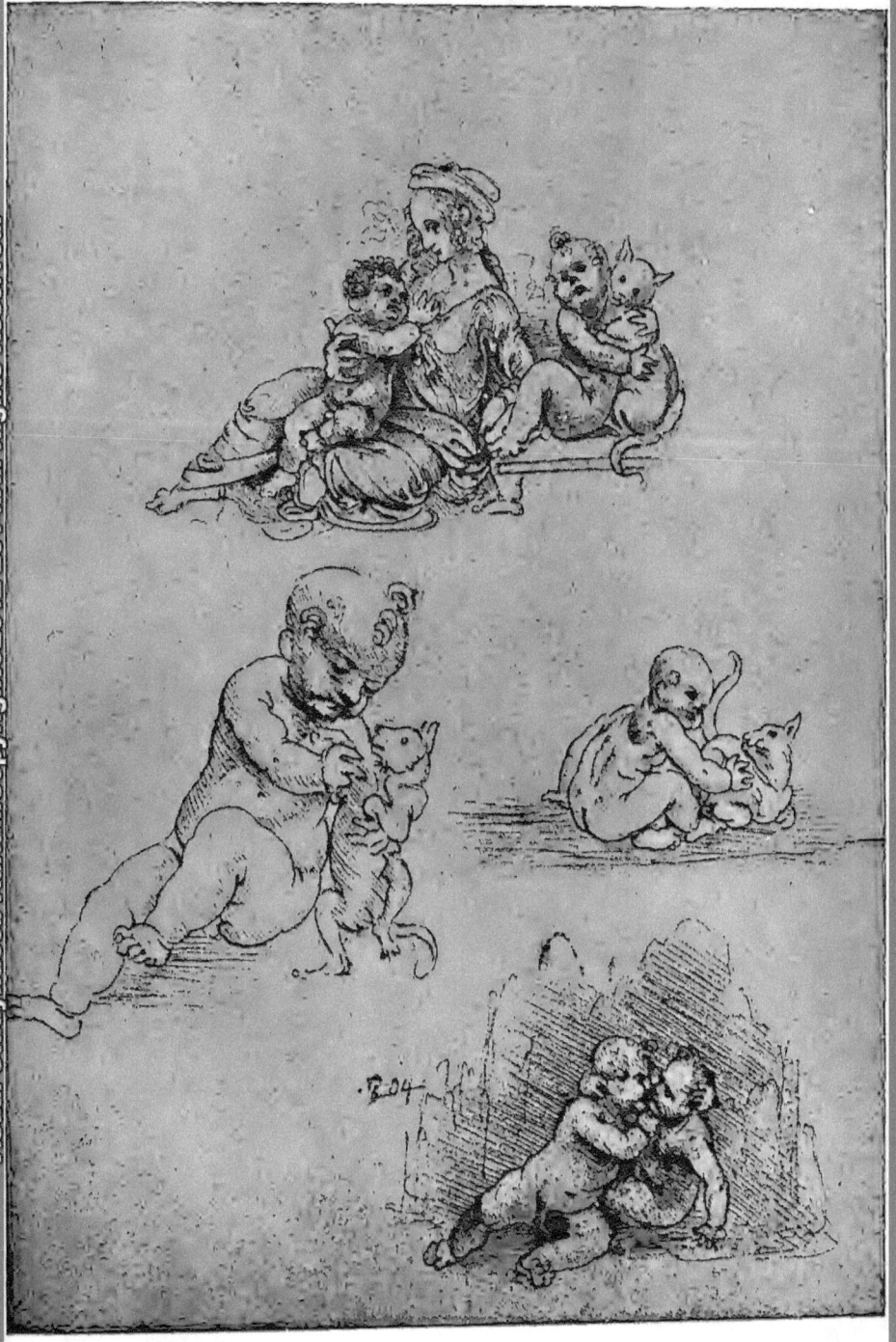

STUDIES FOR "THE HOLY FAMILY"
(WINDSOR)

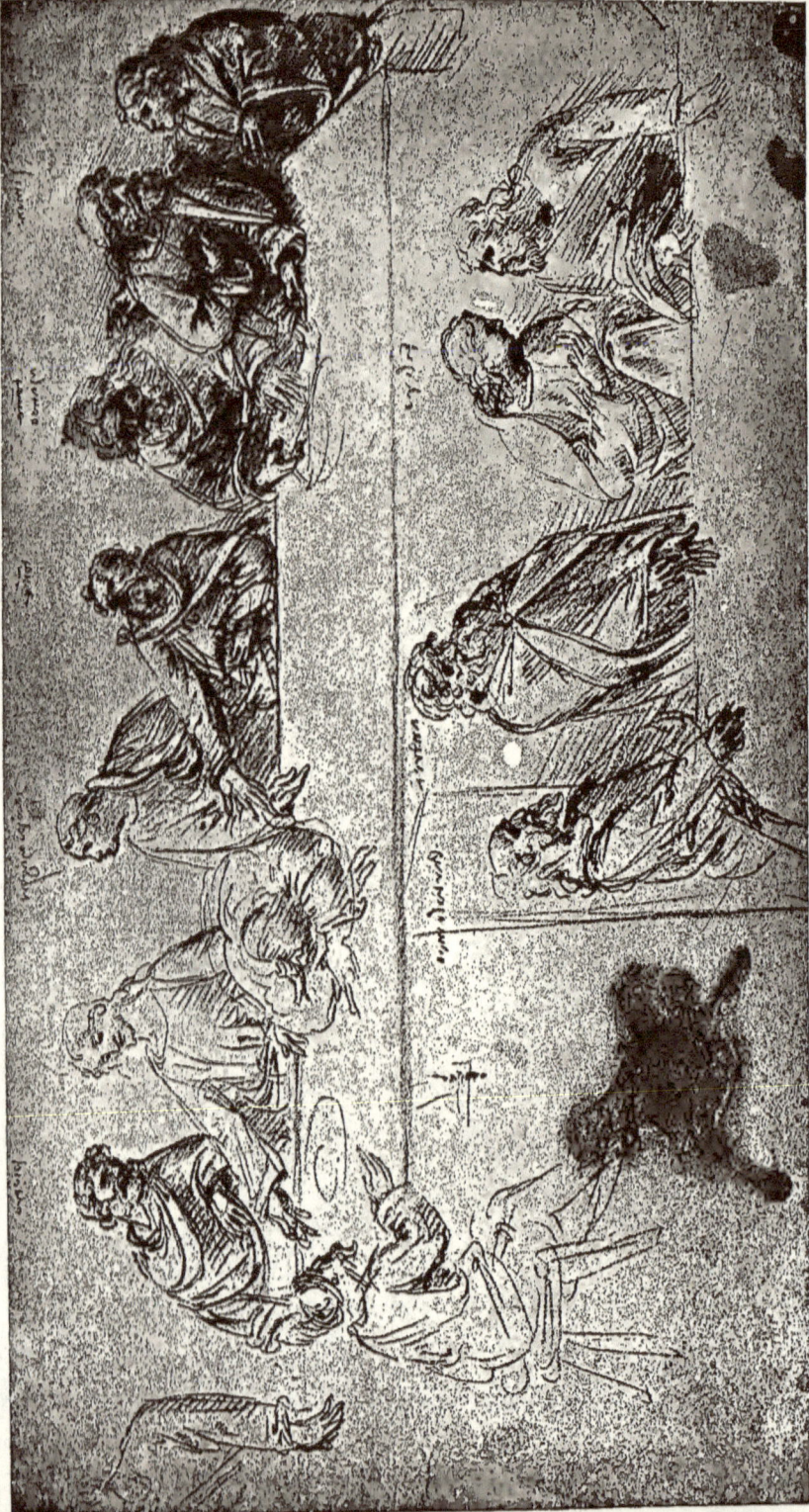

STUDY FOR "THE LAST SUPPER" (ACADEMY, VENICE)

COURTYARD OF A CANNON-FOUNDRY (WINDSOR)

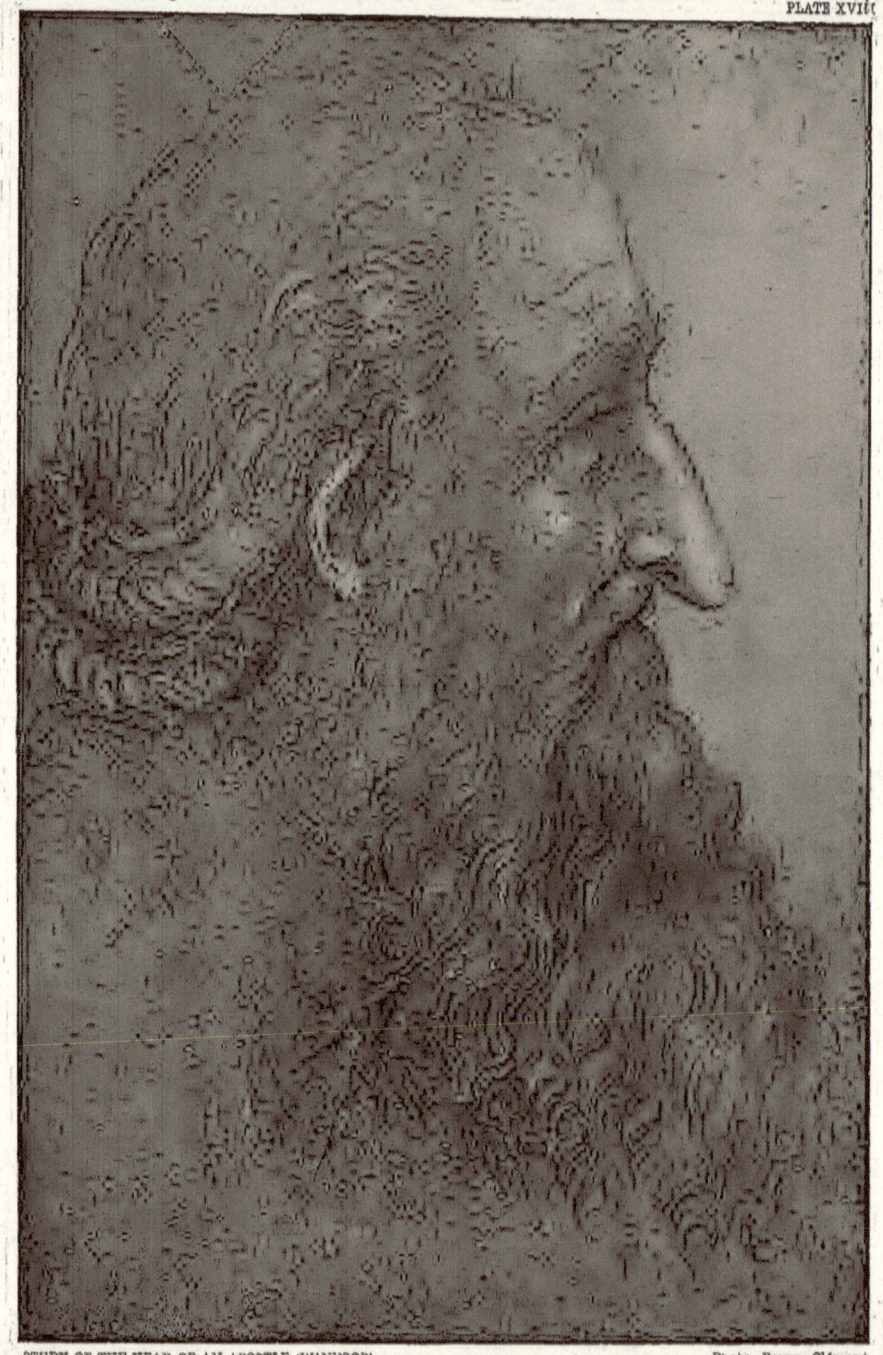

STUDY OF THE HEAD OF AN APOSTLE (WINDSOR)

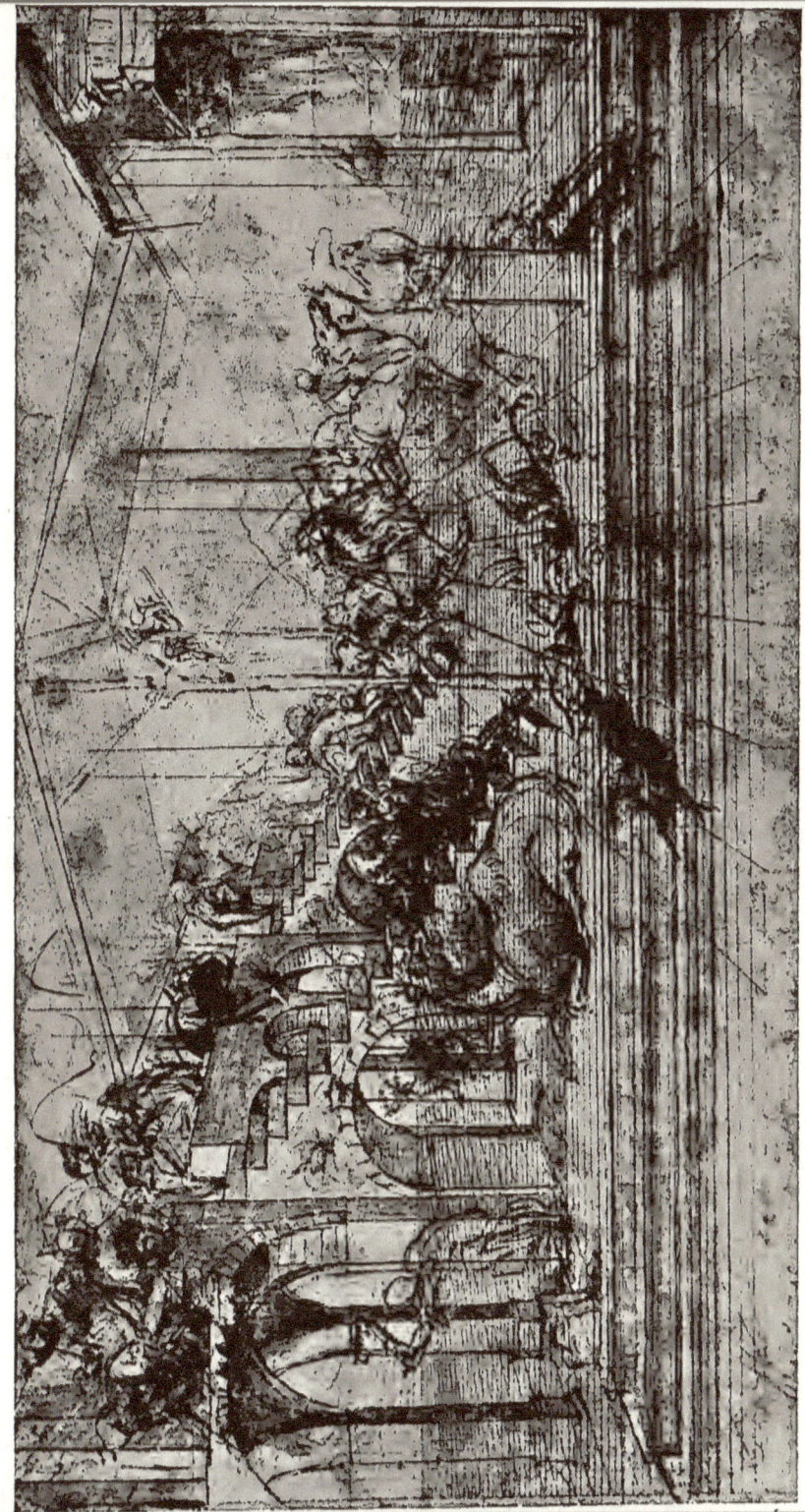

STUDY FOR BACKGROUND OF "THE ADORATION OF THE MAGI" (UFFIZI, FLORENCE)

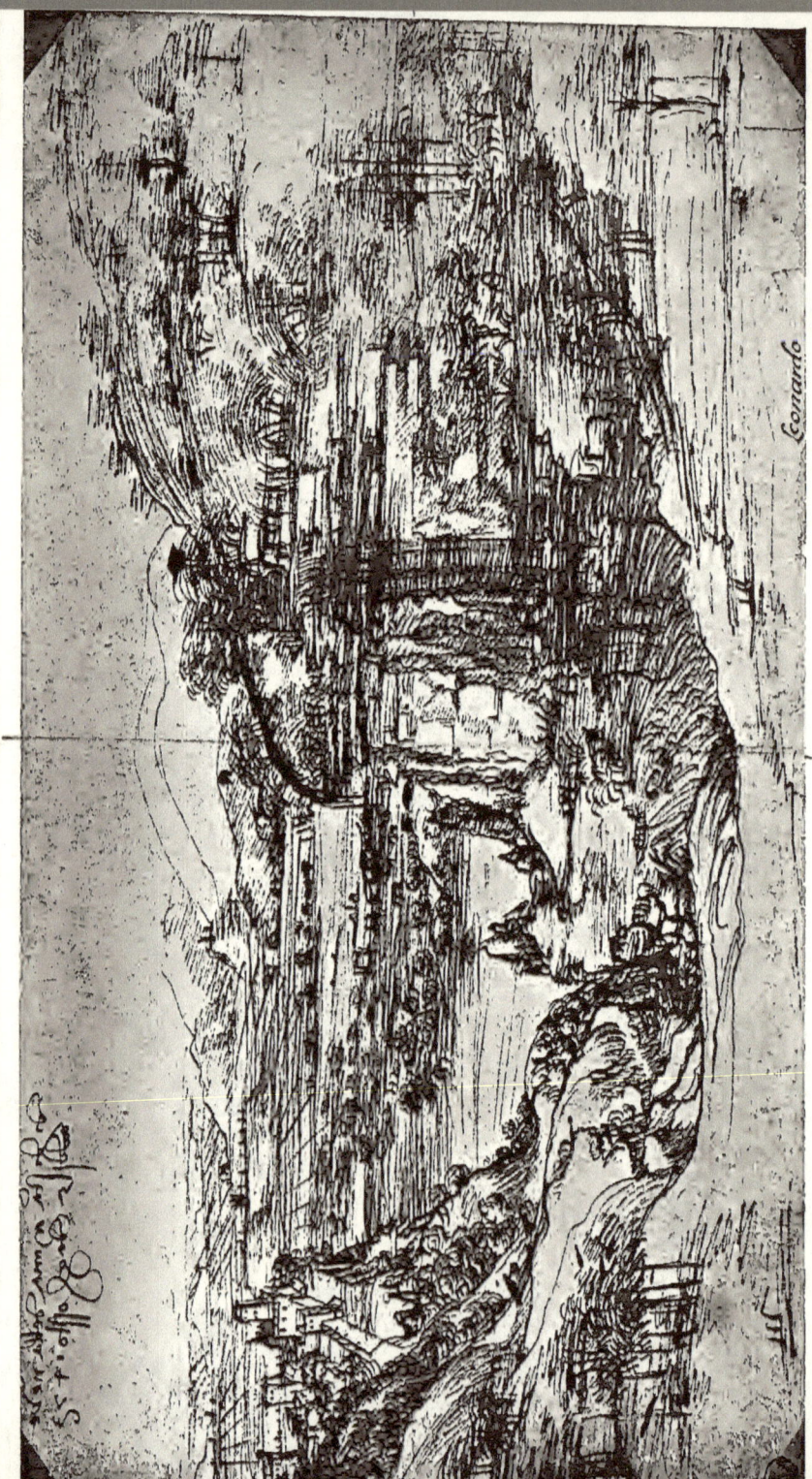

STUDY OF LANDSCAPE. DATED 1473. (UFFIZI, FLORENCE)

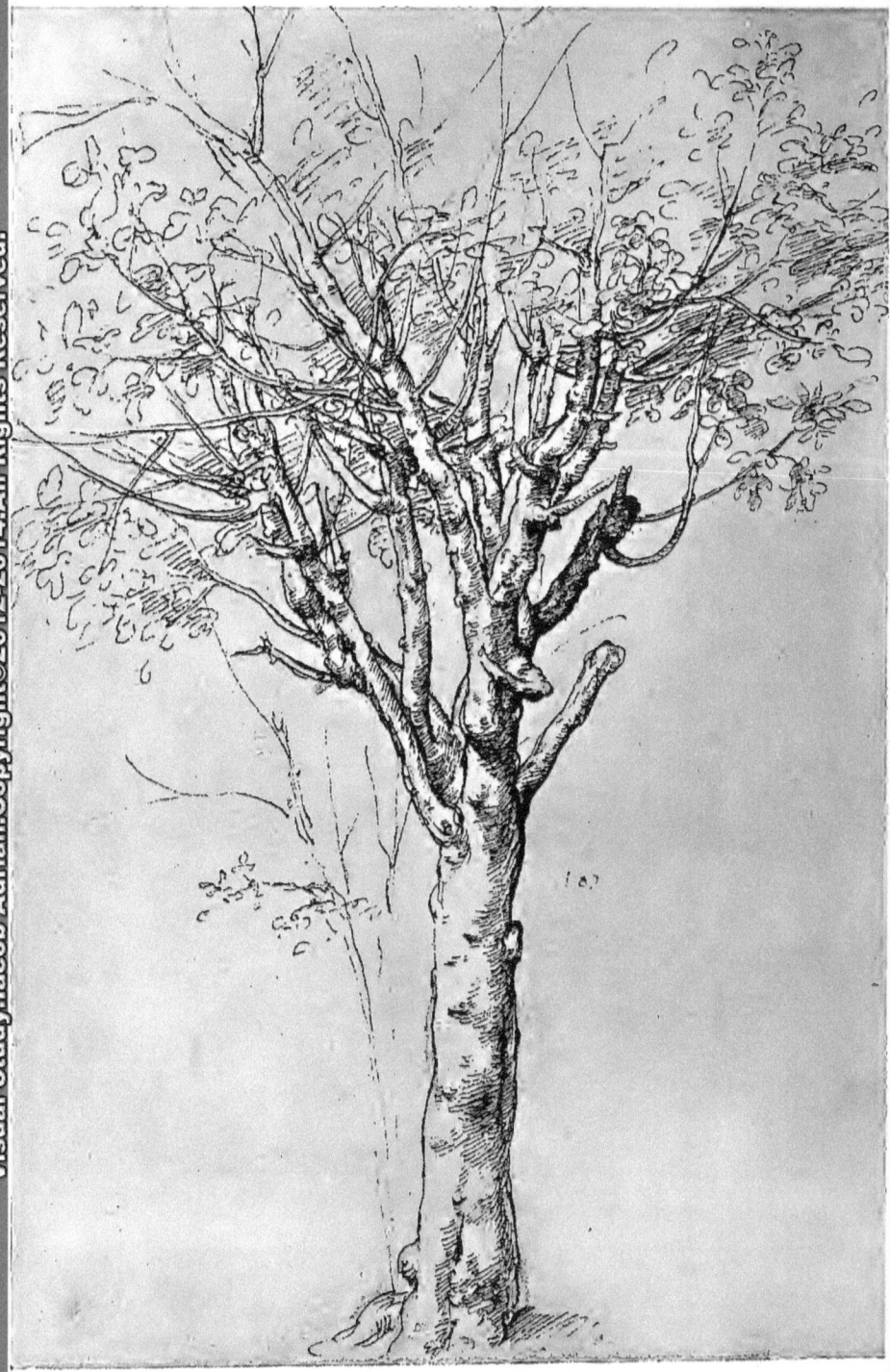

STUDY OF A TREE (WINDSOR)

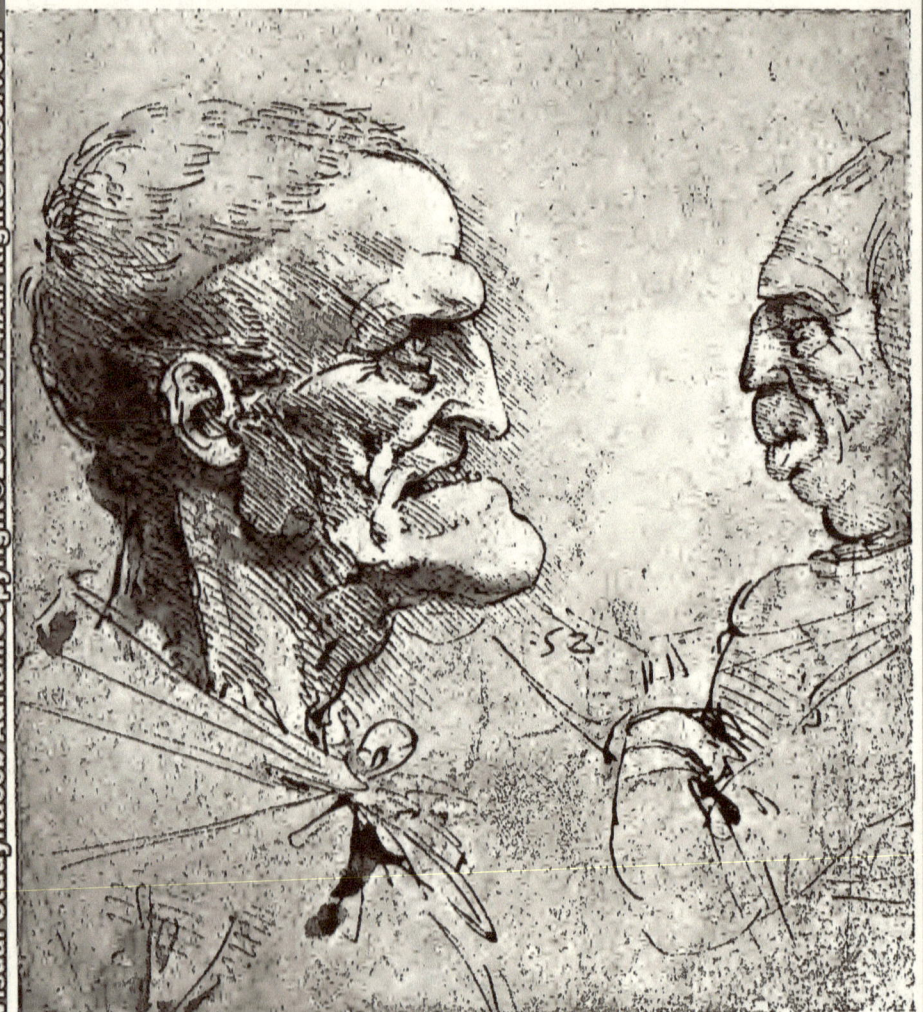

TWO HEADS. CARICATURES (WINDSOR)

PLATE XXIII

ST. JOHN THE BAPTIST (WINDSOR)　　　　PHOTO, BRAUN, CLÉMENT

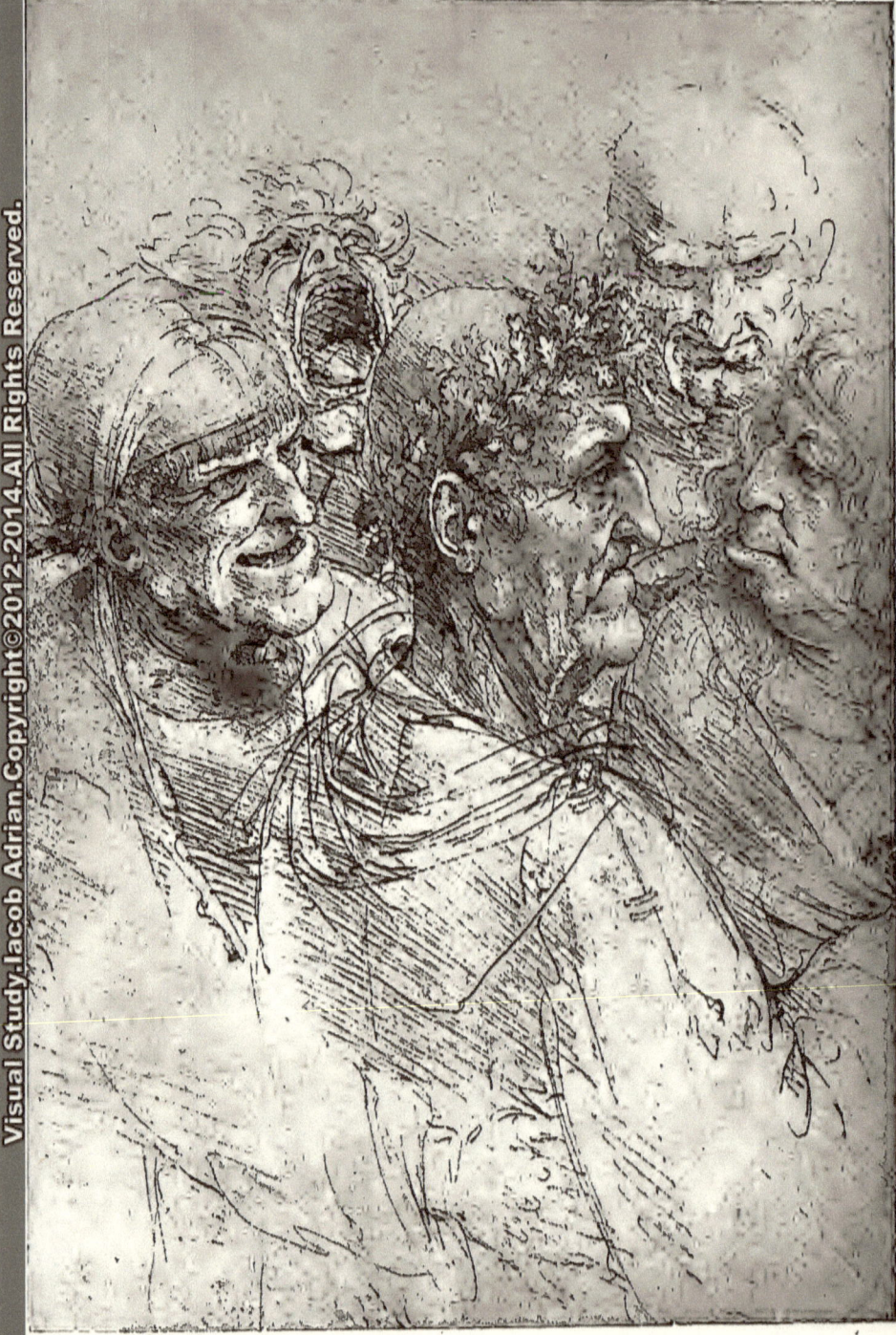

CARICATURES (WINDSOR)

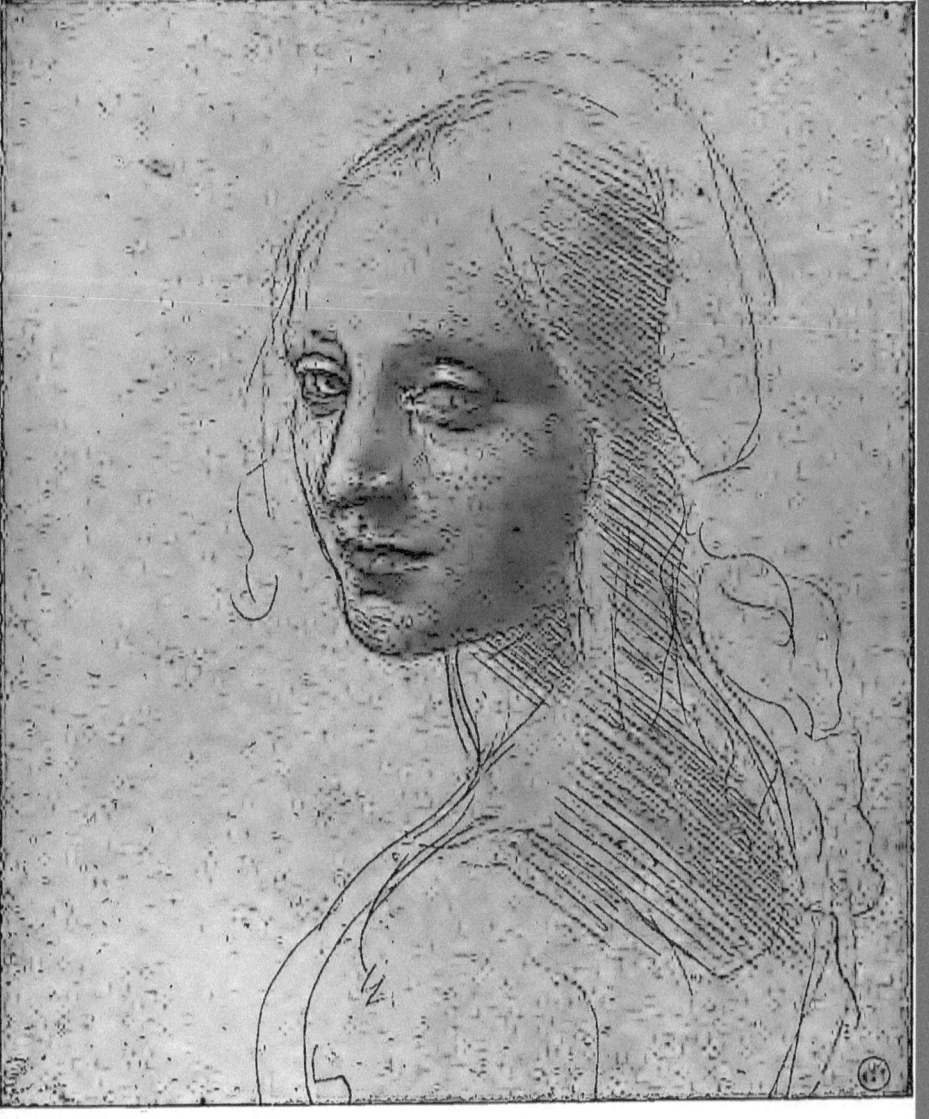

PLATE XXVI

HEAD OF AN ANGEL (TURIN)

PHOTO, ANDERSON

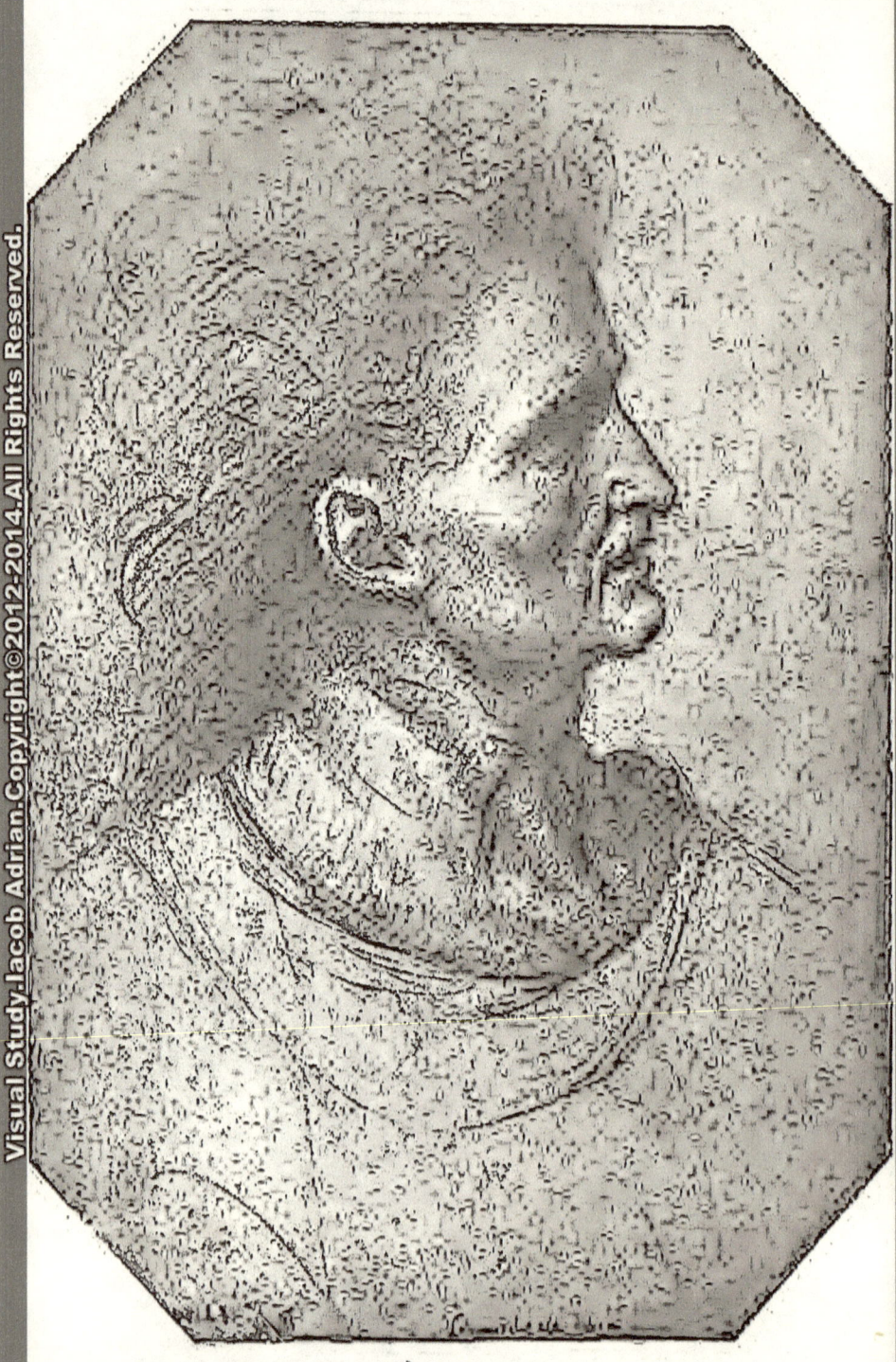

STUDY OF A MAN'S HEAD (BRITISH MUSEUM) PHOTO, BRAUN, CLÉMENT

PLATE XXVIII

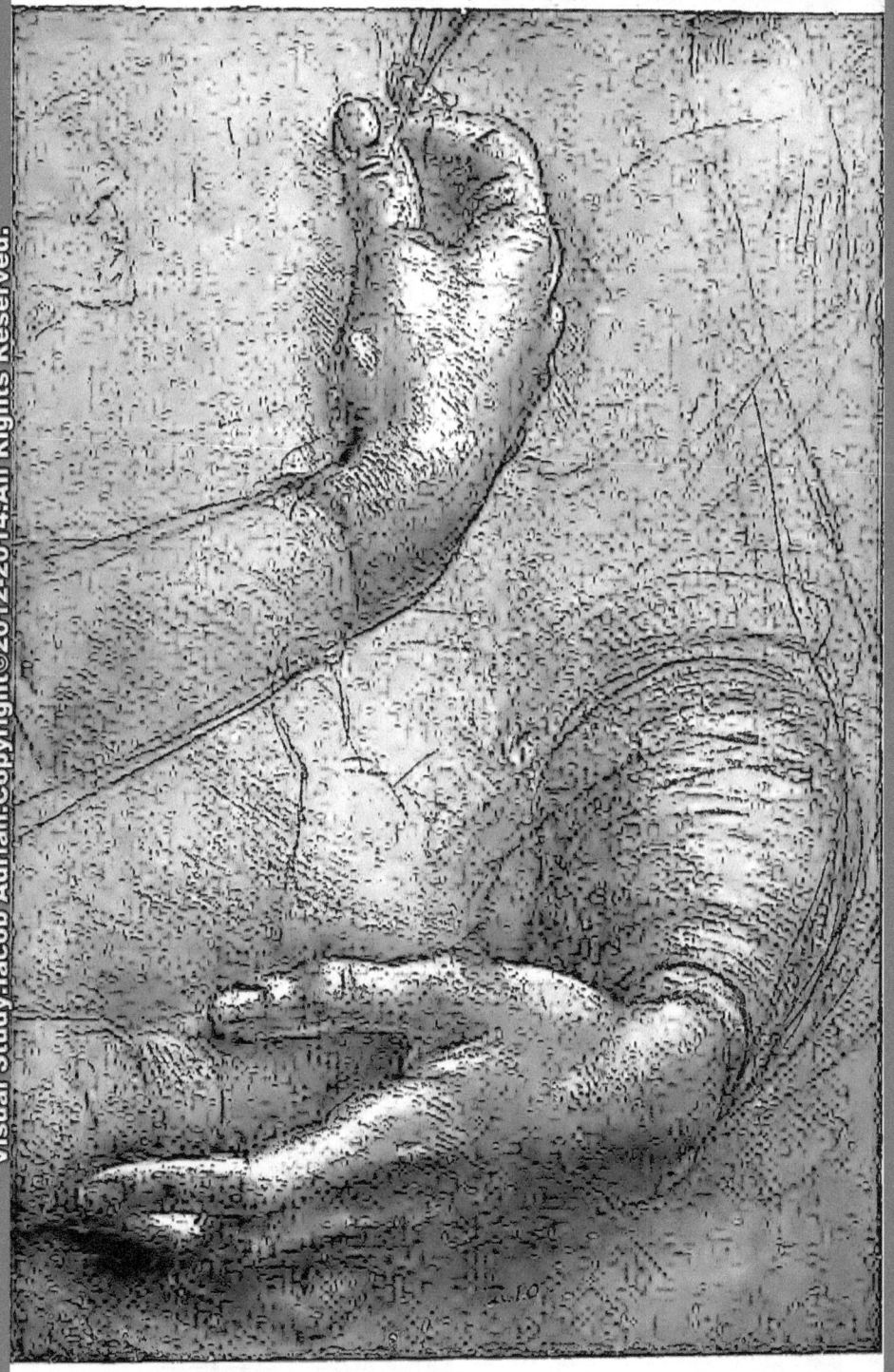

STUDIES OF HANDS (WINDSOR)

PHOTO, BRAUN, CLÉMENT

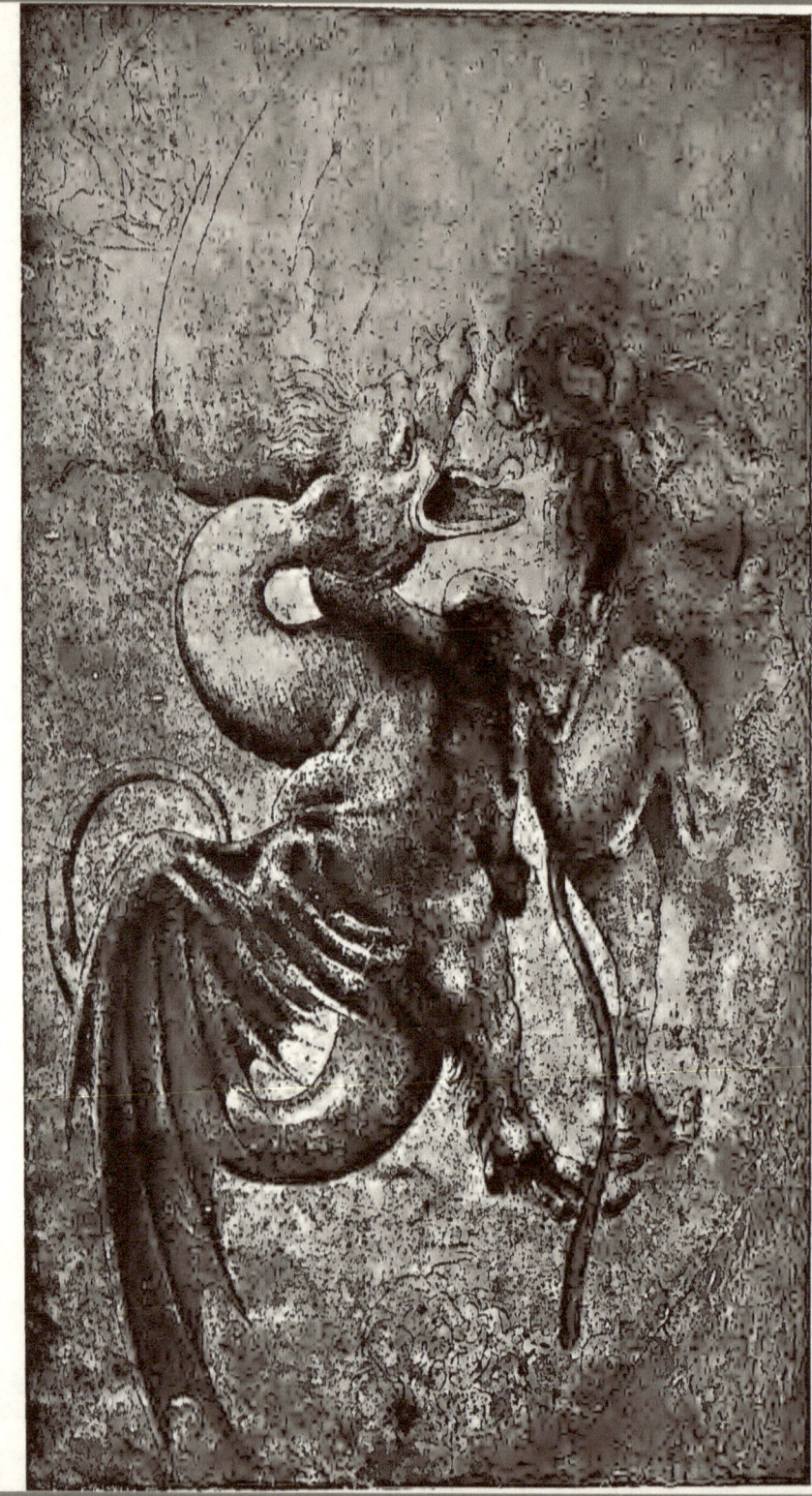

DRAGON FIGHTING WITH A LION (UFFIZI, FLORENCE)

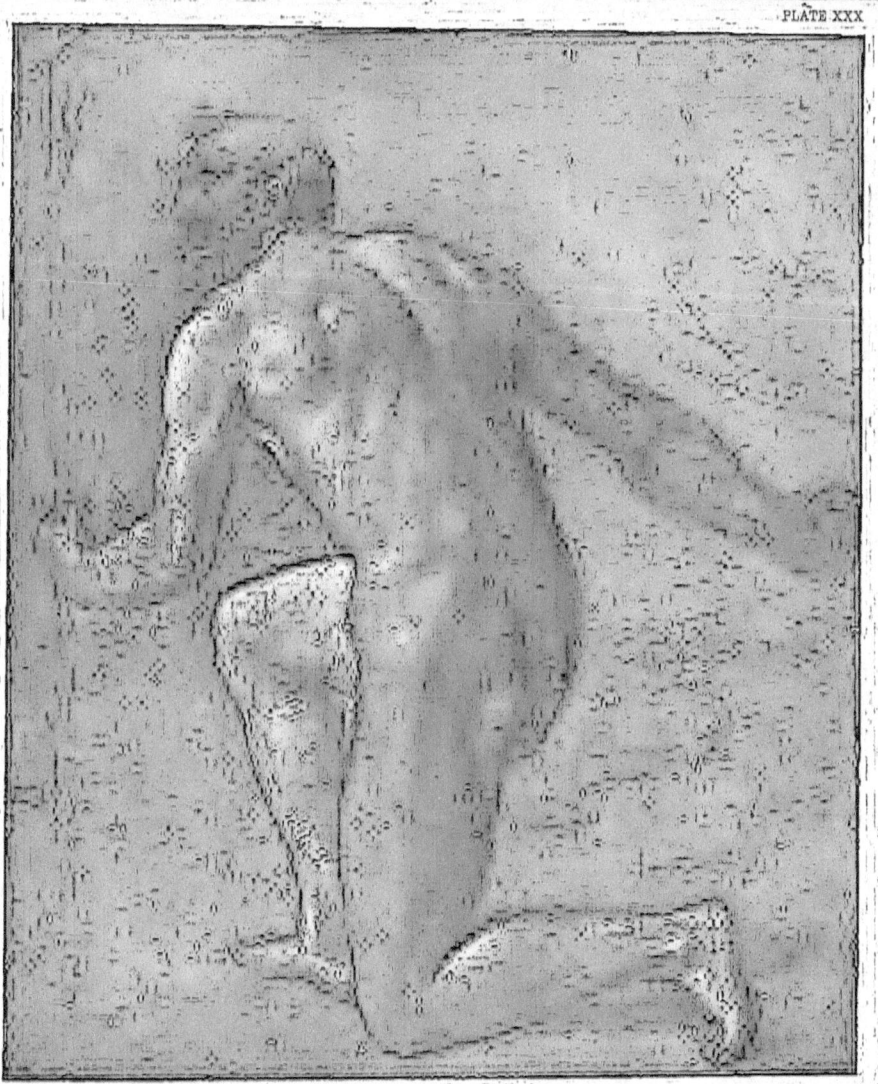

MAN KNEELING (WINDSOR) — Photo, Braun, Clément

PLATE XXX

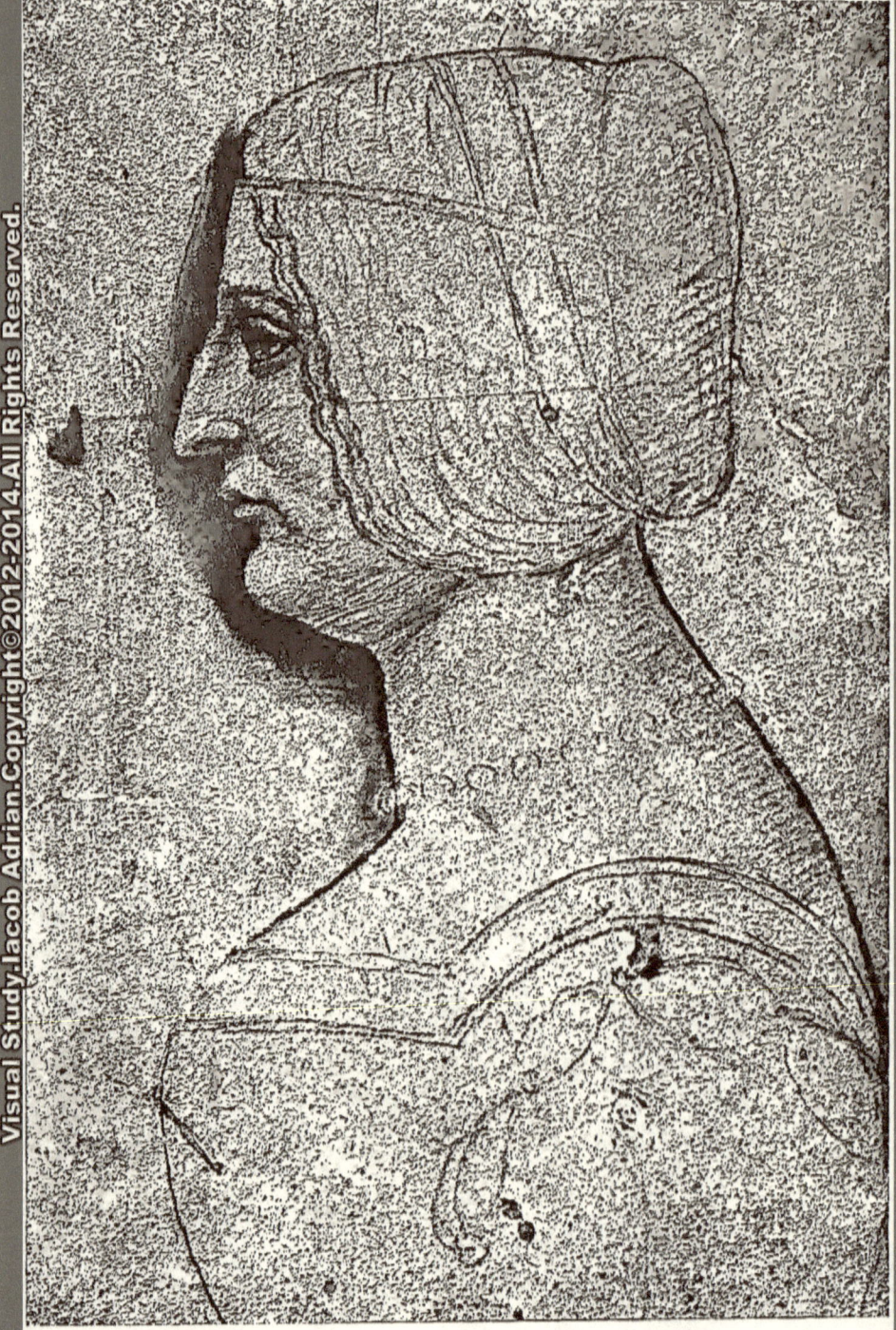

PORTRAIT STUDY (MILAN)

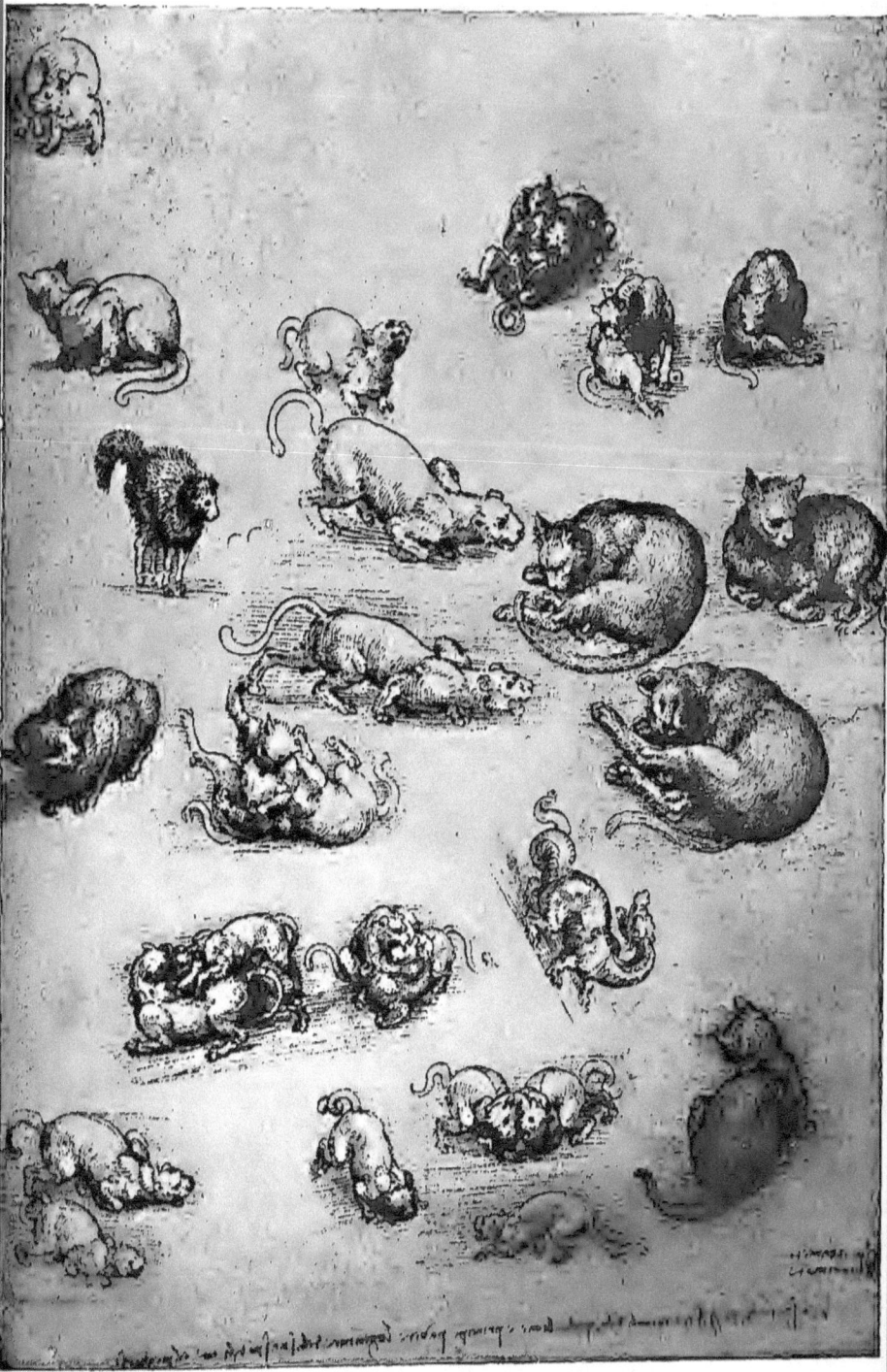

STUDIES OF ANIMALS (WINDSOR)

PLATE XXXIII

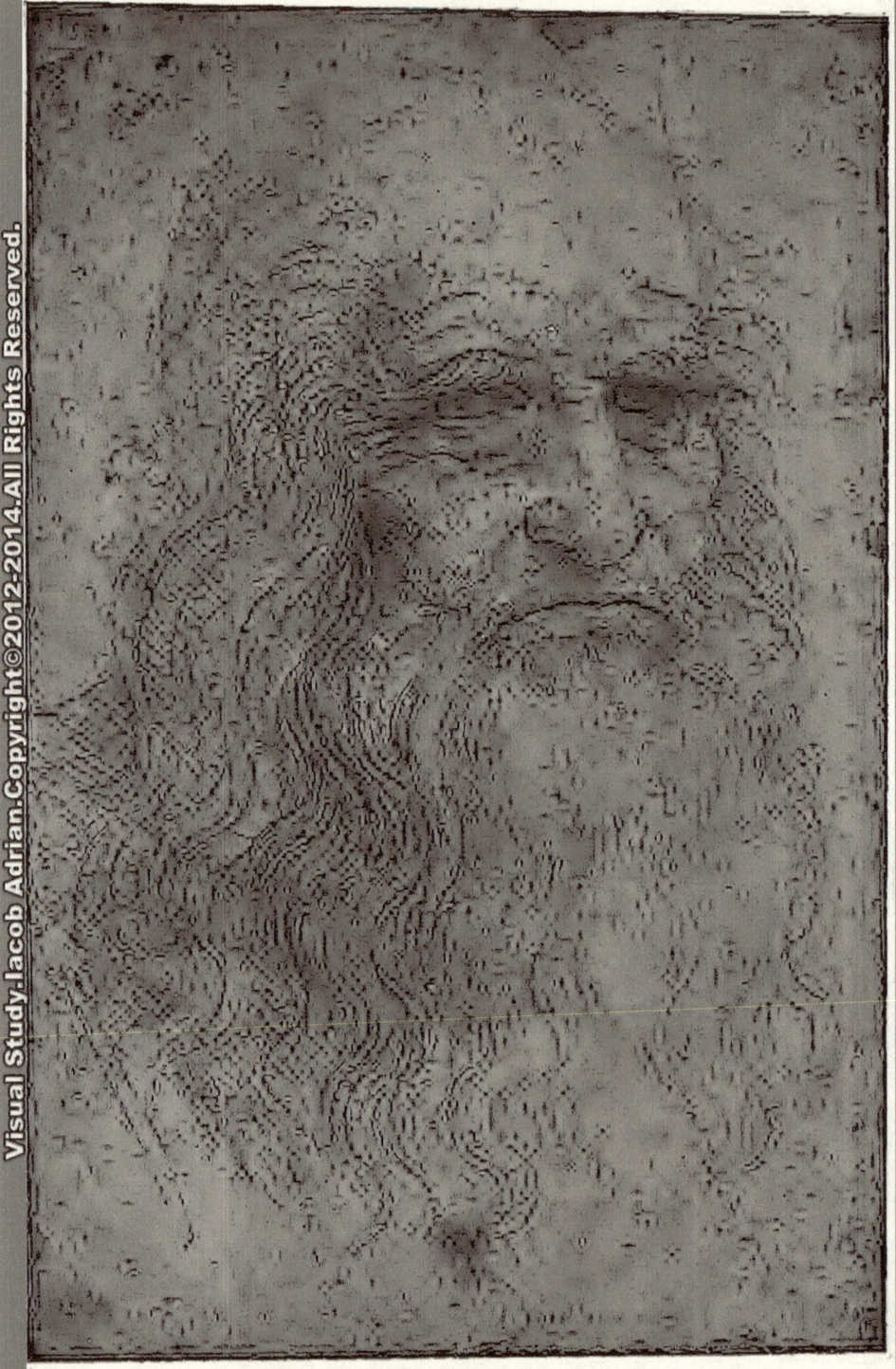

PORTRAIT OF LEONARDO, BY HIMSELF (TURIN)

PHOTO, ANDERSON

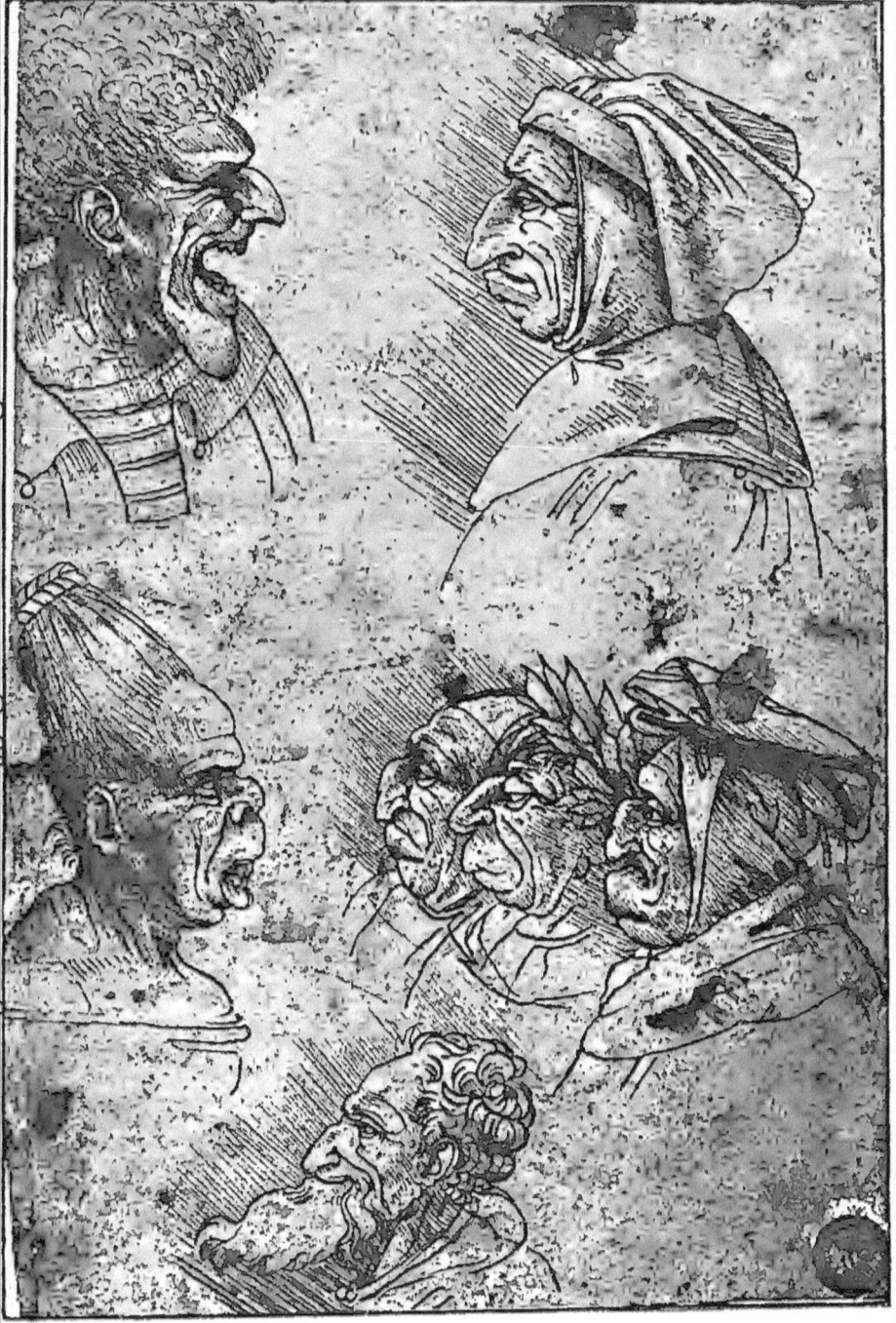

SIX HEADS OF MEN AND A BUST OF A WOMAN
CARICATURES (VENICE)

STUDY OF A HEAD (UFFIZI, FLORENCE)

PLATE XXXVI

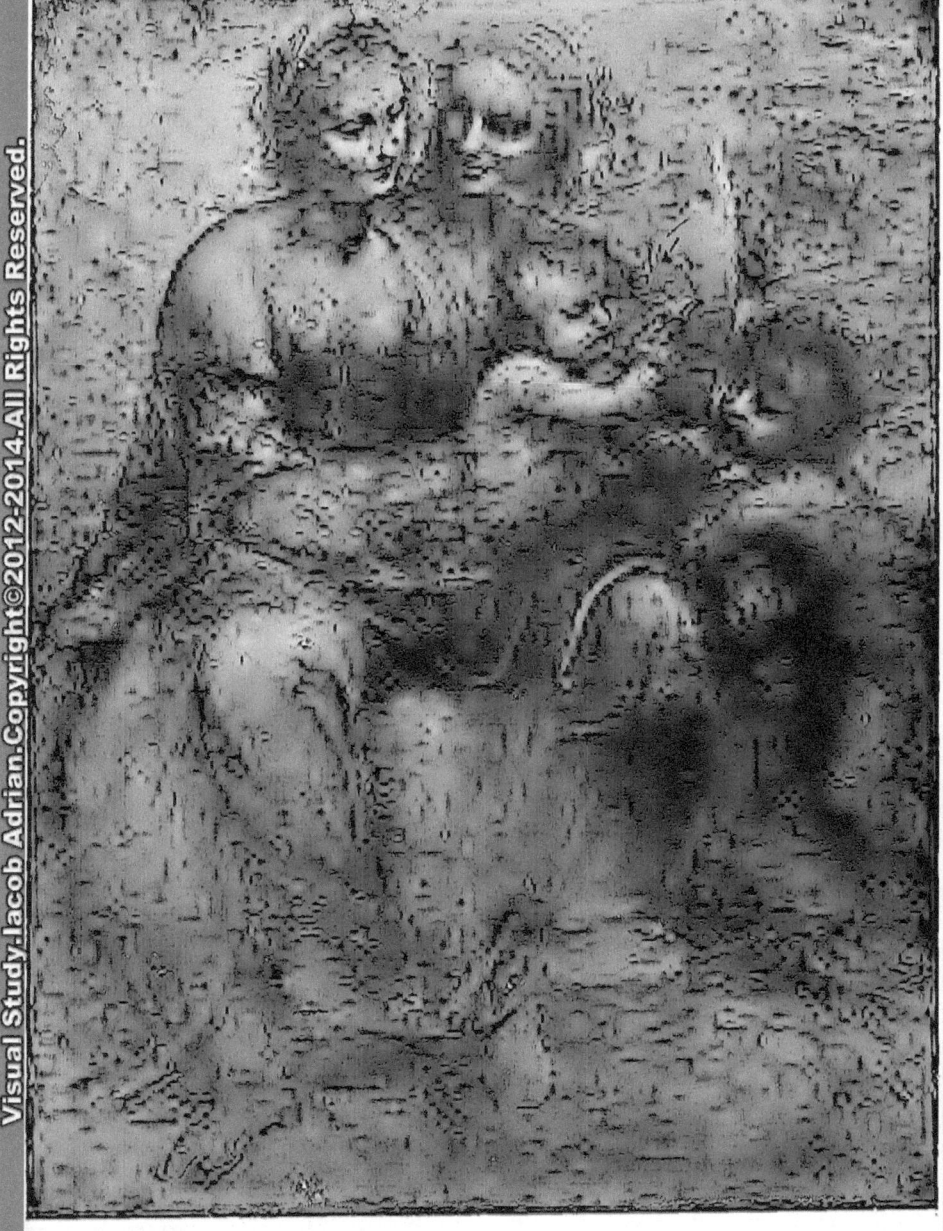

THE SAINT ANNE CARTOON
(BURLINGTON HOUSE)

PHOTO, HOLLYER

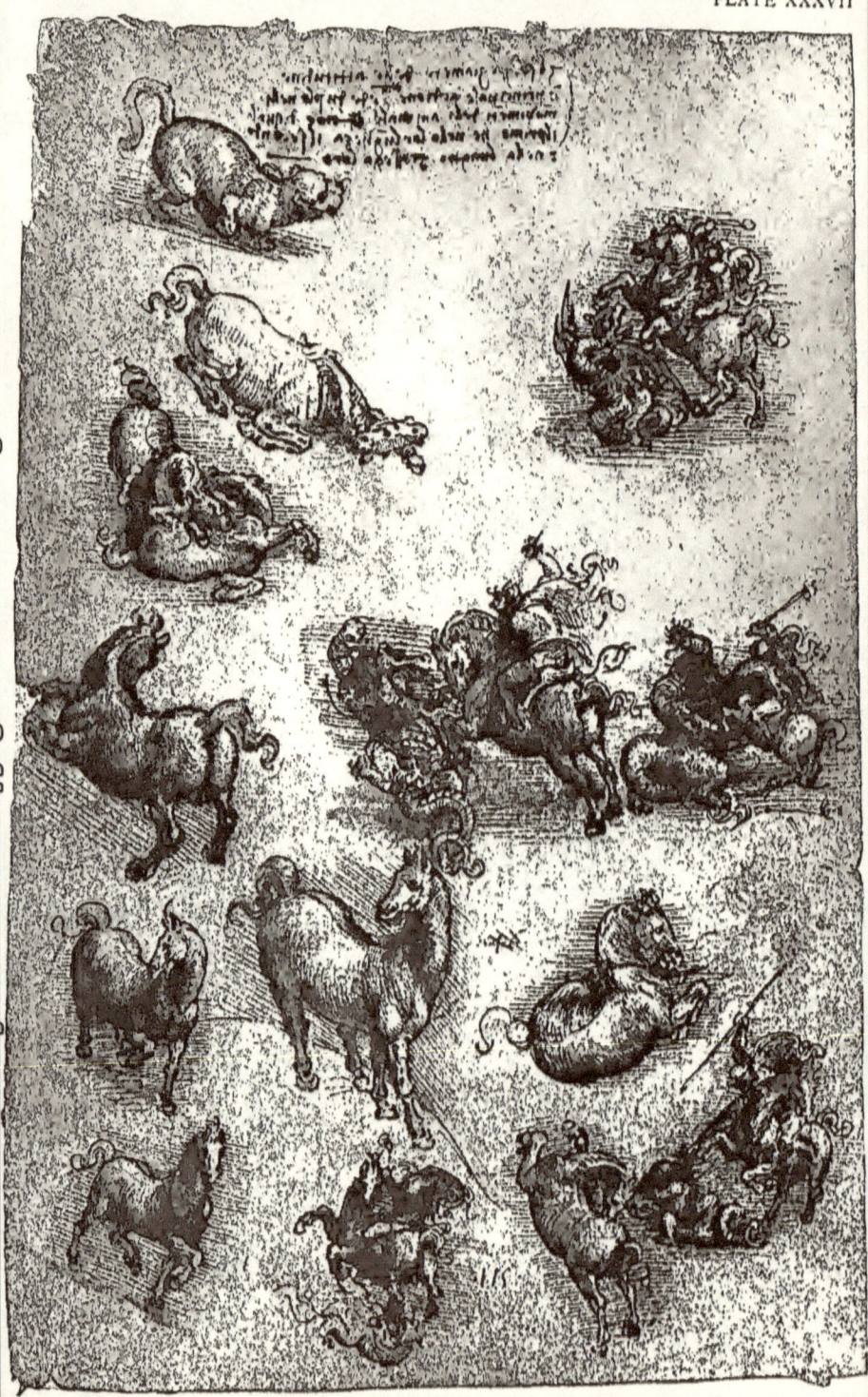

STUDIES OF HORSES (WINDSOR)

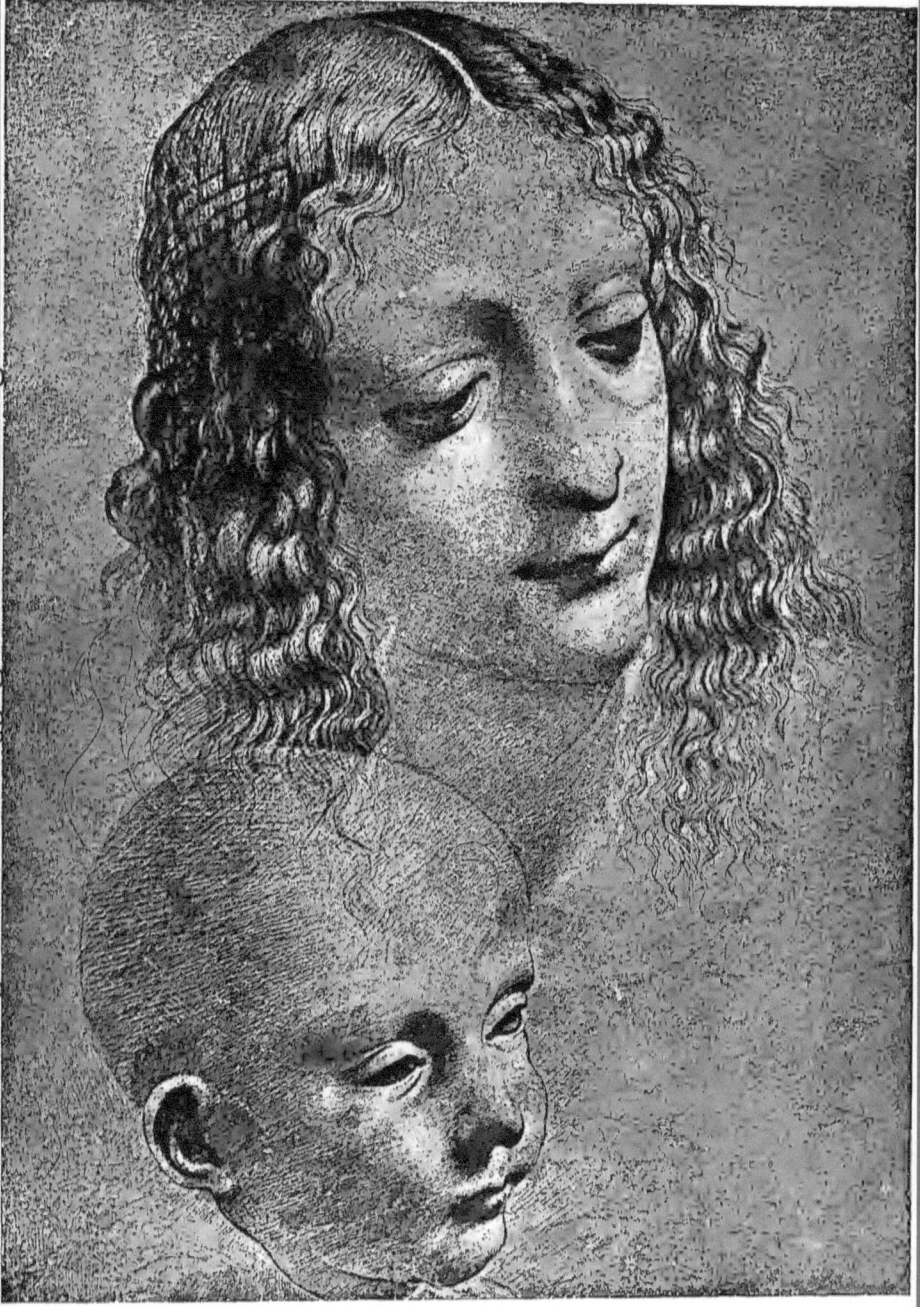

HEADS OF A WOMAN AND A CHILD (CHATSWORTH)

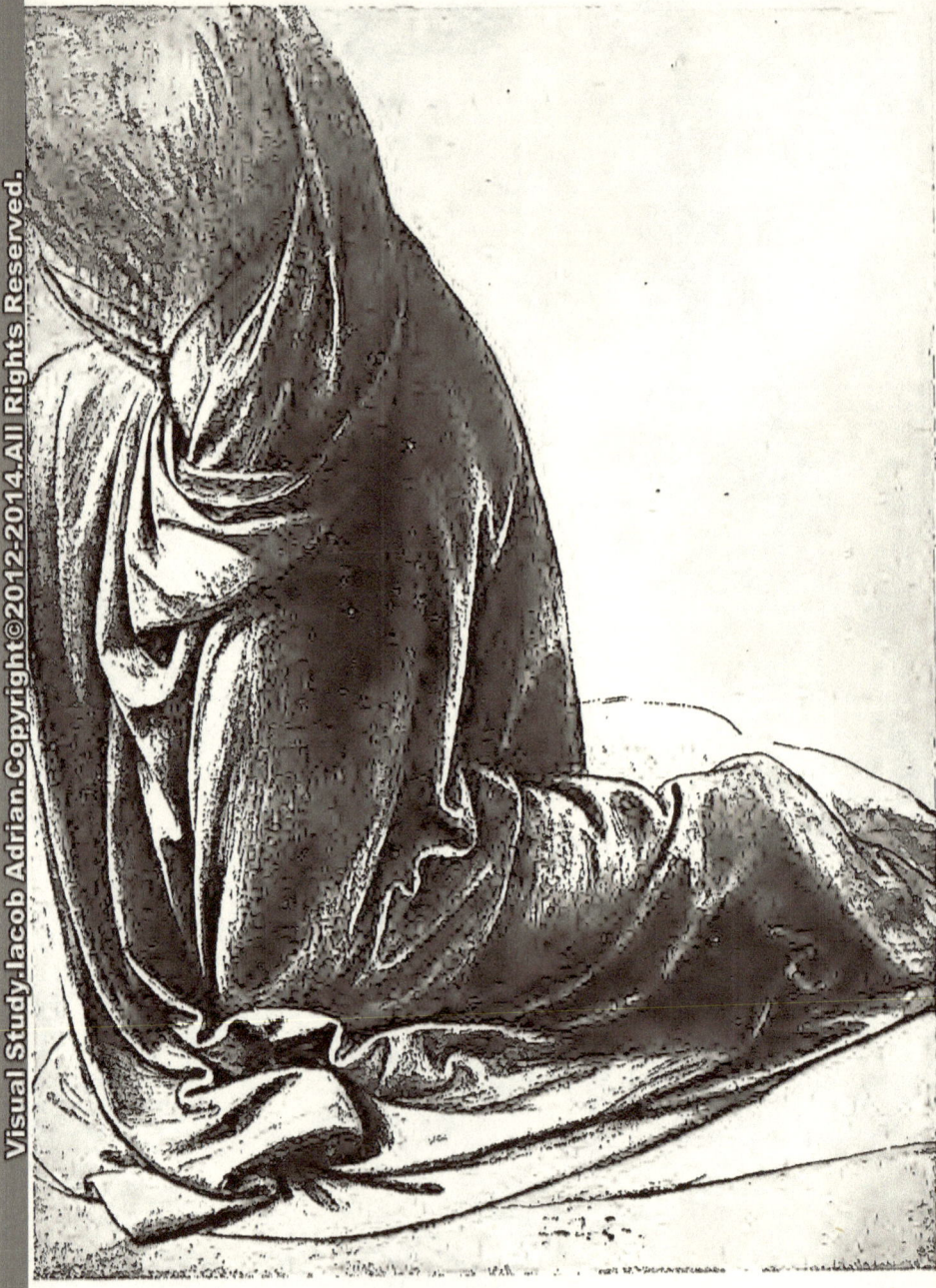

STUDY OF DRAPERY FOR A KNEELING FIGURE
(WINDSOR)

PLATE XL

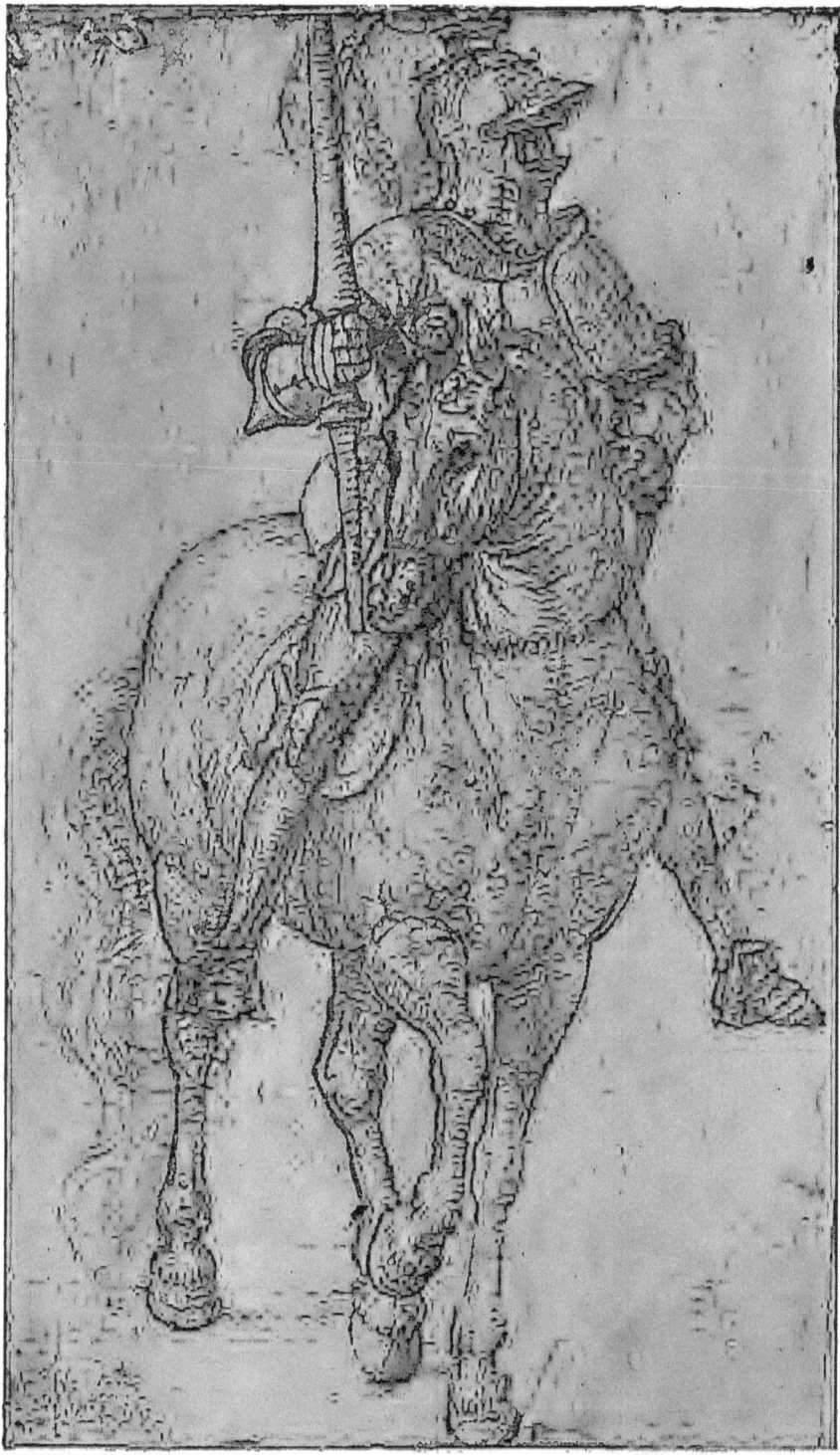

KNIGHT IN ARMOUR (MILAN) Photo, Braun, Clement

PLATE XLI

STUDY OF A YOUTHFUL HEAD (BRITISH MUSEUM)

PHOTO, AUTOTYPE COMPANY

PLATE XLII

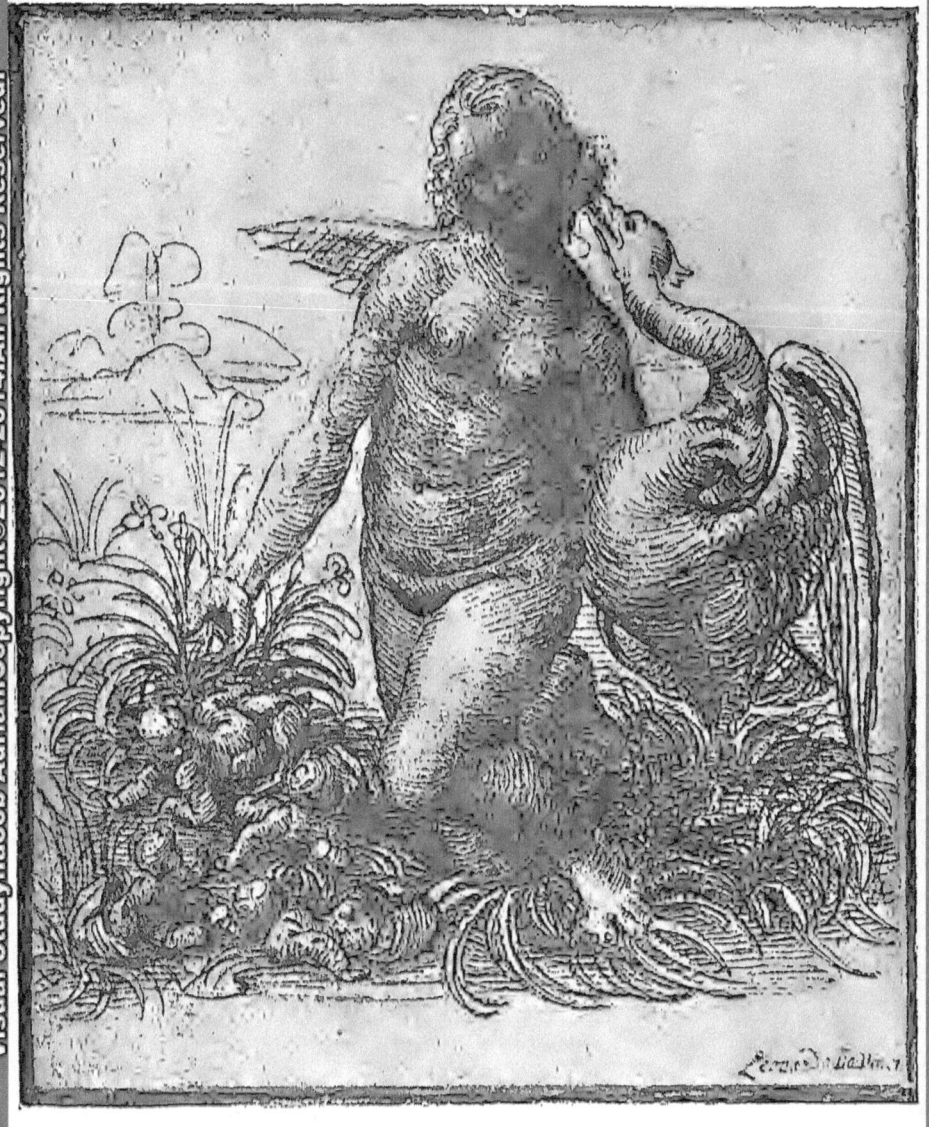

STUDY FOR "LEDA" (CHATSWORTH)

PHOTO, BRAUN, CLÉMENT

PLATE XLIII

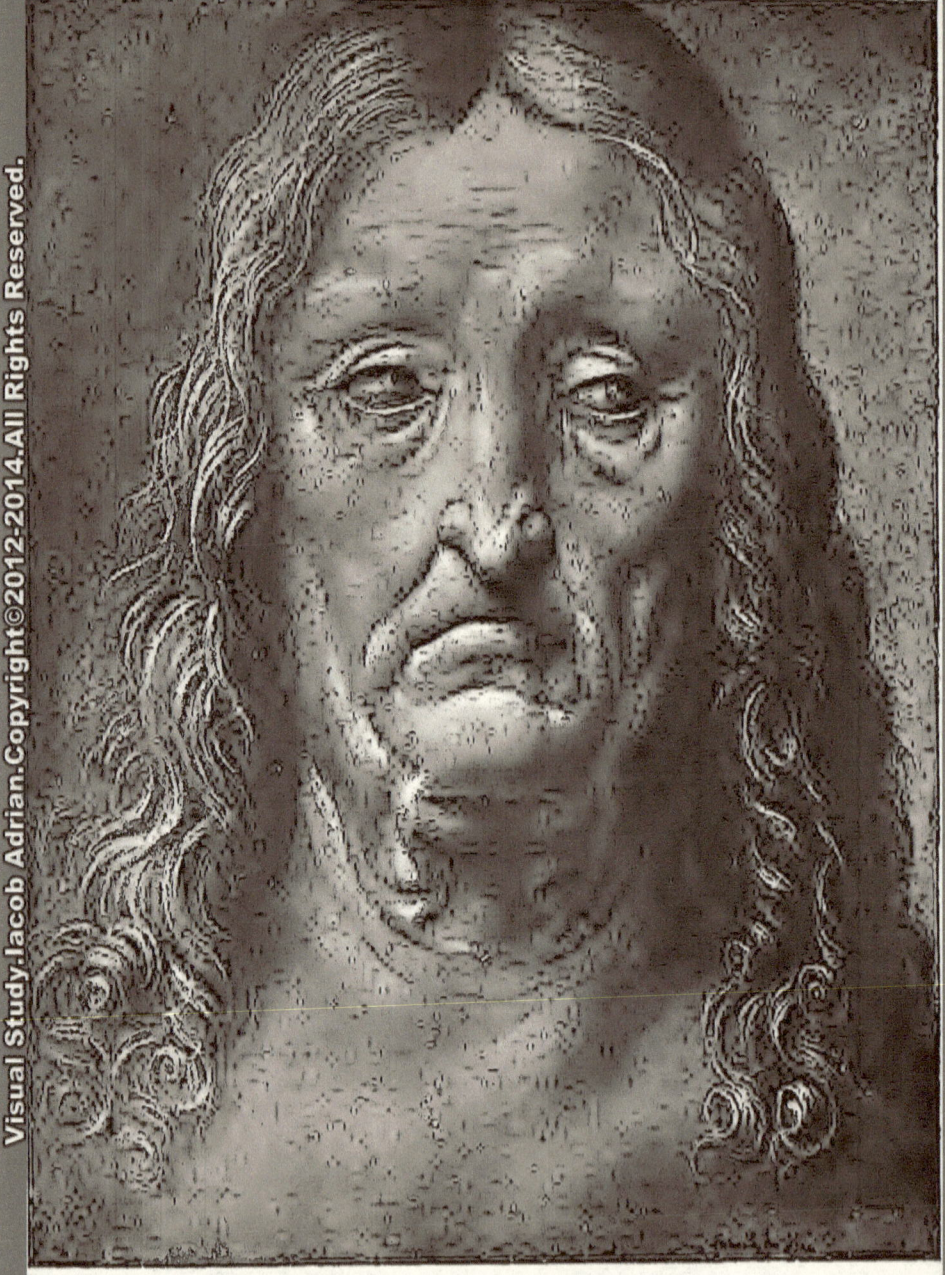

HEAD OF AN OLD MAN (WINDSOR)

PHOTO, BRAUN, CLÉMENT

PLATE XLIV

STUDY OF A HEAD (WINDSOR) PHOTO, BRAUN, CLÉMENT

STUDY OF THE HEAD OF ST. PHILIP FOR
THE LAST SUPPER (WINDSOR)

PHOTO, BRAUN, CLÉMENT

PLATE XLVI

STUDY OF DRAPERY (LOUVRE) PHOTO, BRAUN, CLÉMENT

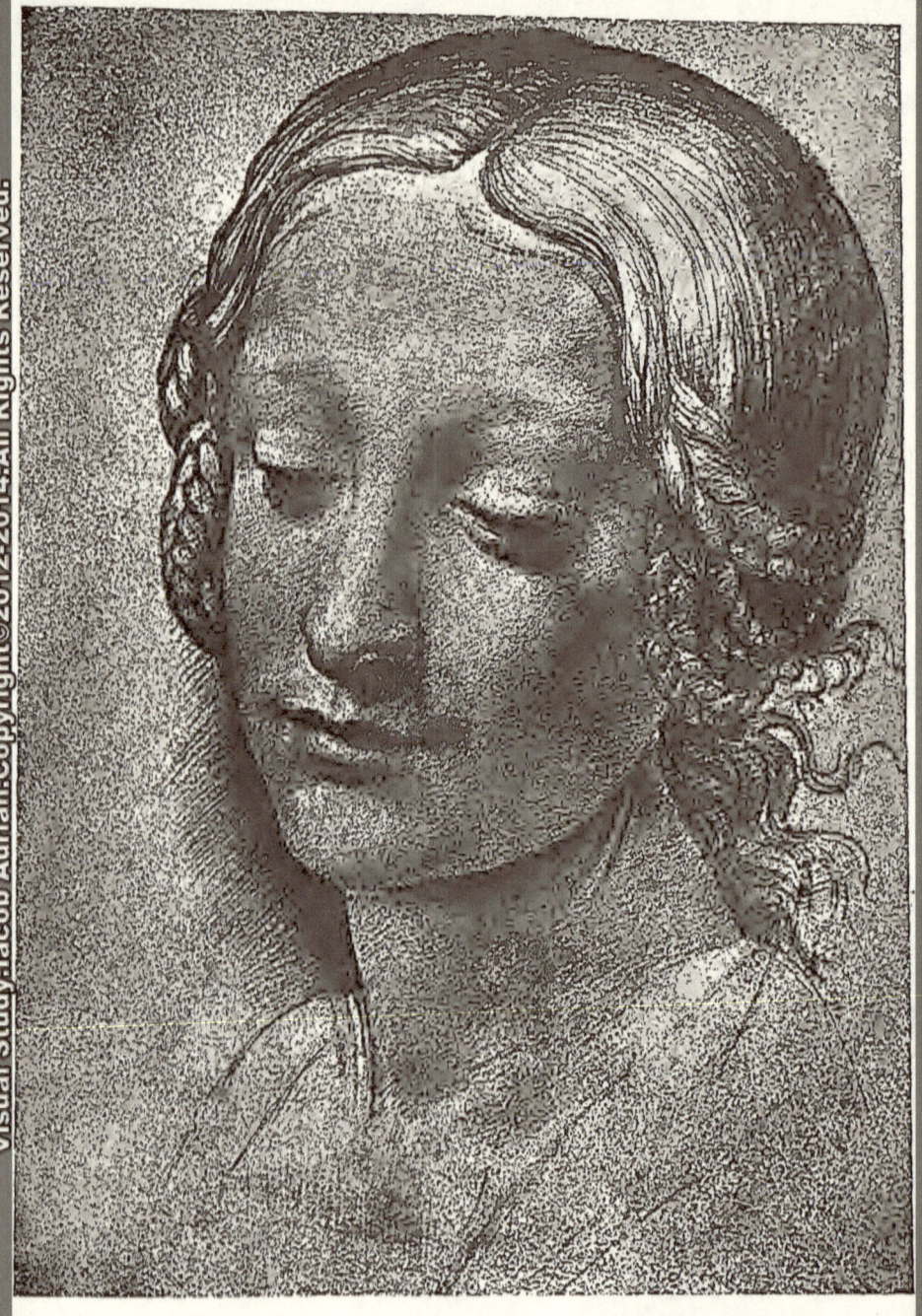

PLATE XLVII

GIRL'S HEAD (MILAN)

PHOTO, BRAUN, CLÉMENT

STUDIES OF A SATYR WITH A LION (MILAN)

Bibliographic sources :

Drawings of Leonardo da Vinci [by Charles Lewis Hind] ([1907])

Author: Leonardo, da Vinci, 1452-1519;
Hind, C. Lewis (Charles Lewis), 1862-1927

Publisher: London G. Newnes

This documentary study use,
combined in various proportions,
elements from the following categories,
forms and subsets :
- fair use
- documentary
- documentary photography
- feature
- journalism
- arts journalism
- visual journalism
- photojournalism
- celebrity photography
in order to :
- employ material as the object of cultural critique ,
- quote to illustrate an argument or point ,
- use material in historical sequence,
providing independent opinion,
using photos, press articles, advertisements,
opinions of fans etc. ...

Copyright©2012-2014 Iacob Adrian
All Rights Reserved.

www.ingramcontent.com/pod-product-compliance
Lightning Source LLC
Chambersburg PA
CBHW021019180526
45163CB00005B/2021